IMAGES
of America

MOSCOW

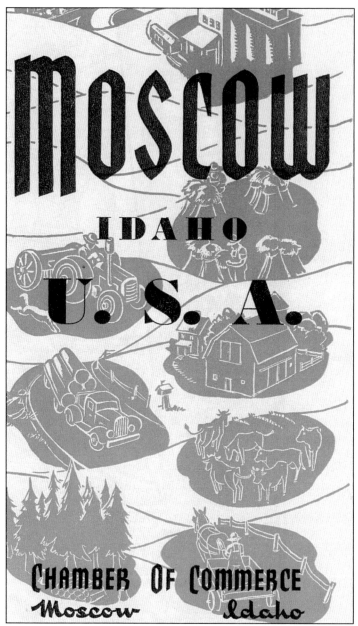

Renowned artist and University of Idaho art professor Alfred Dunn designed this cover image for a 1950 Moscow Chamber of Commerce brochure. According to the brochure's contents, "Moscow is a home city—an ideal family town."

ON THE COVER: The funeral cortege for a Moscow citizen named Bue rests outside his home on Howard Street. Little is known about Mr. Bue, whose home is believed to have been located between what are now Third and Fifth Streets. According to information on the back of this photograph—unique to the Latah County Historical Society for its subject matter—Bue was born on November 26, 1823, and died on that same date in 1904.

IMAGES
of America

MOSCOW

Julie R. Monroe

ARCADIA
PUBLISHING

Published by Arcadia Publishing
Charleston, South Carolina

Printed in the United States of America

Library of Congress Catalog Card Number: 2006931268

For all general information contact Arcadia Publishing at:
Telephone 843-853-2070
Fax 843-853-0044
E-mail sales@arcadiapublishing.com
For customer service and orders:
Toll-Free 1-888-313-2665

Visit us on the Internet at www.arcadiapublishing.com

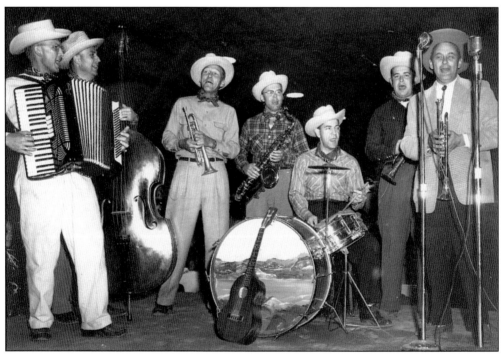

During the 1950s, members of the Moscow Boosters Band express their support of high school athletics through country swing. Pictured, from left to right, are Alf Robinson, Byron Henry, Darrell White, unidentified, Clyde Culp, unidentified, and Lee Connelly, who, according to information on the back of this photograph, was "leader & front man." Connelly established "North Idaho's Most Interesting Store," Tri-State, in Moscow in 1946. This general merchandise and sporting goods store is still in business today.

CONTENTS

ACKNOWLEDGMENTS

The author acknowledges a profound debt to those individuals who helped forge Moscow's historic identity, especially Lillian Otness. This book could not have been written without her book, *A Great Good Country*. The author also thanks the Latah County Historical Society for its generosity in providing images for this book. Because the historical society was the predominant source of photographs for this book, photographic credit has been provided only when the source was not the Latah County Historical Society. I have tried to ensure accuracy throughout, and I welcome corrections and additional information.

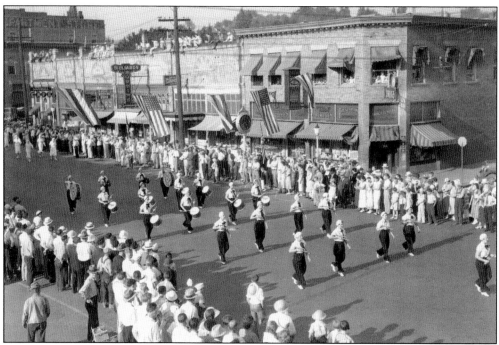

Members of a drum and bugle corps march down Main Street during a parade sponsored by the American Legion sometime in the 1930s. The building in the right background of this photograph, at the intersection of Third and Main Streets, still stands. Around 1880, Gottfried Weber built a wooden structure on this site to house his harness business. Around 1909, merchant George Creighton replaced Weber's building with a two-story brick one that was later renovated as a result of a fire in the 1940s.

INTRODUCTION

Moscow always has been a special place—a place with seemingly boundless prairies that provided the first peoples, the Nimiipuu or Nez Perce Indians, with an abundant source of one of their most important foods, the camas plant. In addition, according to Nimiipuu elder Allen Slickpoo, Moscow was favored because it was where the mule deer fawns, or *taxt*, spent their first summers:

> "The People would look up from digging camas, and "poof! a little taxt would leap out of the bushes. A few more roots in the basket, another look up to rest the back and—poof!—another little taxt would pop up. Every summer it went like that, and soon the *Nimiipuu* knew the name for this place—*Taxt-hinma*—the place of the mule deer fawns."

The area's early permanent settlers, arriving in the last decades of the 19th century, also felt deeply connected to this special place. Charles J. Munson, who would go on to become one of Moscow's—and Idaho's—most respected citizens, arrived as a young man in Moscow in 1884. Upon his first sighting of this village in the heart of the Palouse, a unique geographic area of fertile rolling hills located in Idaho, Washington, and Oregon, he knew he had come to the place where he would stay: "Here I would have a home, if ever so humble. Here I would raise my family of boys and girls, and here I would be buried when I died."

Over a century later, Munson's frontier village is now a vital university town of nearly 22,000 people. Home of Idaho's land-grant institution, the University of Idaho, Moscow is a community that looks to the future, while maintaining a strong sense of historic identity.

Brothers Almon and Noah Lieuallen are generally credited with founding Moscow upon their arrival in 1871. Two years later, when the first post office was established, Moscow was actually called Paradise. However, by 1876, the name of the community had become Moscow, probably because an early settler, Samuel Neff, chose the name in honor of his birthplace in Moscow, Pennsylvania, when he was filling out the form to apply for a post office.

Moscow's city center—its downtown commercial district—was established around 1876 when Almon Lieuallen, James Deakin, Henry McGregor, and John Russell donated 30 acres of their homestead claims at the point where each met at what is now the intersection of Main and Sixth Streets. Moscow's first businesses were housed in simple wooden structures, vulnerable to fire, and hardly emblematic of a community populated by businessmen who dreamed of developing the community into a commercial center that would serve farmers and ranchers throughout the Palouse region.

As early as 1877, area farmers had discovered that the soil blanketing the undulating Palouse landscape was rich with nutrients. Wheat grew especially well, and for many decades, it was the crop most commonly cultivated. Around 1910, however, farmers began experimenting with legumes, which proved so successful that today, the Palouse produces nearly all the nation's dried peas, lentils, and chickpeas.

When locally produced bricks first became available in 1885, Moscow merchants at last had a building material that would do justice to their aspirations. The establishment of the University

of Idaho in Moscow in 1889 secured the town's future, and its commercial leaders then began a downtown building boom that resulted in the erection of a number of distinctive brick buildings, especially along Main and Third Streets.

Today much of this architectural fabric of early Moscow remains intact. In fact, if William J. Shields—one of Moscow's most successful early businessmen—was to appear miraculously today on Main Street (mumbling, "I'm Michael J. Shields, by God; I'm Michael J. Shields, by God," as is said to have been his habit!), he might not be as disoriented as one would think. Moscow's architectural legacy of 19 historic buildings and two historic districts (including a Main Street commercial district) is a daily and visible reminder of the community's economic and cultural heritage.

With the help of the Latah County Historical Society, this book celebrates Moscow's heritage—its progression from a 19th-century frontier village to a typical American "town and gown" community that not so typically toyed with the idea of changing its name during the height of the cold war in the 1950s. It is a collection of historic photographs from the historical society's image archives that documents the town through the first decades of its existence.

This volume is organized in the same way that most Moscowans have traditionally defined their lives: by work, home, play, worship, and fellowship. With Moscow's high proportion of students, thanks to the considerable presence of the University of Idaho, it is fitting that the book also contains a chapter called "In Class," which documents the community's educational legacy. And to provide an initial orientation (and because they're so compelling) to its physical layout, the book begins with an assortment of aerial and panoramic photographs of Moscow.

Once a humble cluster of houses and sheds huddled together and surrounded by vast fields of camas, today Moscow is no longer isolated. It is still surrounded by the breathtakingly beautiful Palouse hills, but Moscow's impact is global. As the community continues to move forward into the 21st century, this book is an effort to give Moscowans a picture of the past in the conviction that the farther back we see, the better forward we can look.

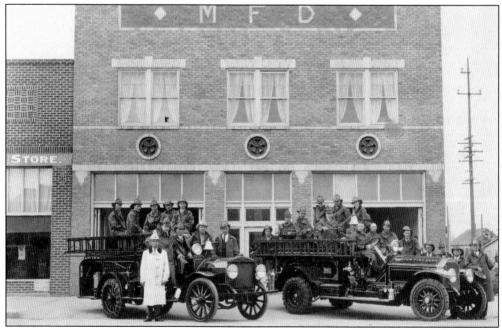

Fire chief Carl Smith (in white coat) and the members of Company No. 6 and Company No. 7 pose in front of the 603 South Main Street station of the Moscow Volunteer Fire Department, c. 1927. According to information on the back of this photograph, the truck on the left is a 1916 chemical truck and the one on the right, a 1922 pumper truck. A second fire station abutting to the south of the one pictured in this photograph dates from 1954.

One

FROM A DISTANCE

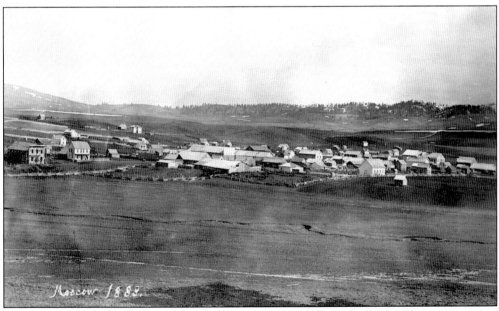

This panoramic view of Moscow is dated 1883, a decade after the establishment of Moscow's first post office in 1873 under the name of Paradise. In 1876, the post office, its name now Moscow, was moved to Almon Asbury Lieuallen's general merchandise store on Main Street. In the interval between 1876 and 1883, when the first issue of the *Moscow Mirror* was published, the community's first church building was erected in 1881, as well as its first brewery, the Moscow Brewery, in 1882.

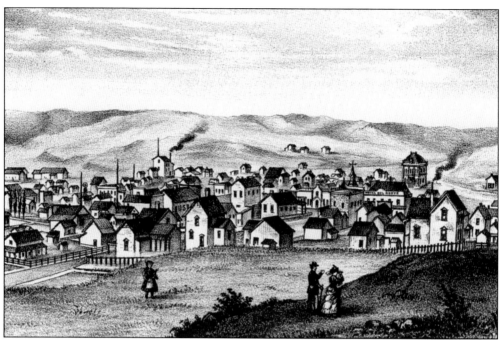

The vantage point of this drawing of Moscow before 1885 looks southwest toward the city center from the site of the town's first school on the corner of A and Adams Streets. Look for the depiction of the Hotel Del Norte on the right. Constructed in 1888 of local red brick, the Hotel Del Norte was Moscow's first brick hotel building. According to Lillian Otness in her architectural history of Latah County, *A Great Good Country*, this building had a second-floor balcony spanning the front and an adjoining hall used by secret societies.

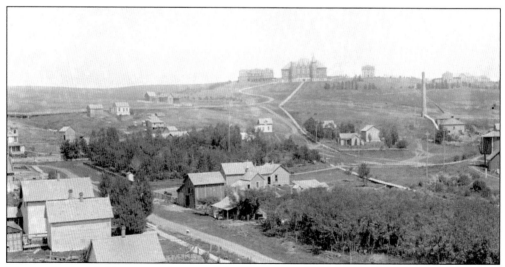

The focal point of this panoramic view of the University of Idaho campus is the Administration Building in the top background of this *c.* 1900 photograph. Located on the site of the present Administration Building, but facing northeast instead of due east, the building consisted of four stories of red brick. The west wing was completed in 1892 and the east wing in 1899. It was destroyed by fire on March 30, 1906.

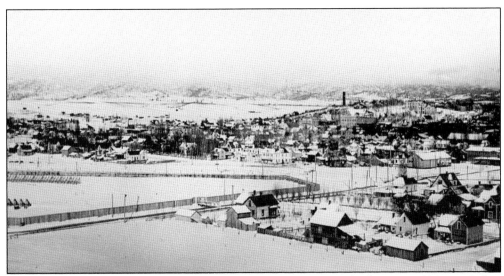

It is believed that this panoramic, *c.* 1900 photograph captures the location of Moscow's first brickyard located between Elm and Ash Streets, south of Sixth Street. Thomas Taylor and Wylie Lauder owned the plant, which furnished brick for Latah County's first courthouse, the first University of Idaho Administration Building, and the first building on the campus of Washington State University in Pullman, Washington, eight miles to the east of Moscow.

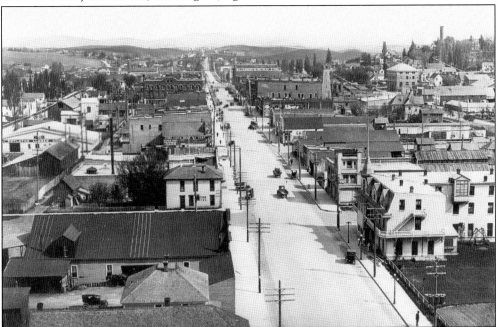

There are two notable structures pictured in this panoramic 1920s view of Moscow's Main Street—the standpipe in the far right background and the fire bell tower at the center right of the photograph. The standpipe, an open cylinder 80 feet tall, served as an air valve for the municipal water system. Built in 1892, it was located in the center of the block bounded by Jefferson, Adams, A, and C Streets and, according to newspaper accounts, was an ideal nesting place for pigeons and swallows. Between 1900 and 1927, the pealing of fire bells, located in towers throughout town, summoned firefighters to their duty.

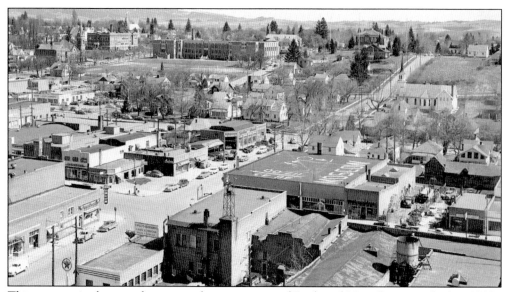

This panoramic photograph captures the intersection of Sixth and Main Streets in the late 1940s. It was at this point that the land holdings of four early permanent Moscow settlers met. The quarter section to the southwest belonged to James Deakin; to the northwest, Almon Asbury Lieuallen; to the northeast, John Russell; and to the southeast, Henry McGregor. According to Otness's *A Great Good Country*, "these four men set aside 30 acres of their farm land as a start for the commercial district." In the background are two notable Moscow buildings: Moscow High School to the left and to the right, the Latah County Courthouse, built in 1889 and replaced in 1958.

In the foreground of this late-1940s panoramic photograph is the roof of the Mark Miller Flour Mill, which was razed in June 1960. Miller arrived in Moscow around 1904 from Nebraska and took over the Cochran and Sons flour mill on the corner of Sixth and Jackson Streets. His "Blue Stem" flour was used primarily for pasta products and was last made on May 13, 1949. On August 6, 1939, there was a fire on top of the mill that could be seen for miles, according to newspaper accounts.

The most notable building in this unique 1950s aerial photograph is Gritman Hospital, now Gritman Medical Center. Construction of the building began in 1938 after a group of citizens formed the Moscow Hospital Association to raise funds to build a community hospital. Named in honor of an early Moscow physician, Charles L. Gritman, the hospital opened in December 1940.

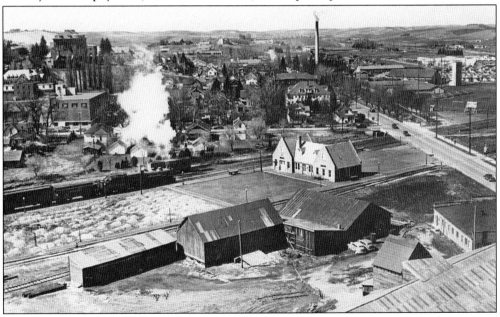

In the center of this c. 1950 aerial photograph is Moscow's passenger train depot. After years of negotiation by members of Moscow's city council, the chamber of commerce, and civic groups, the Northern Pacific and Union Pacific railroads agreed to share a single depot facility. Union Pacific passenger service had ended in 1957, and while the Northern Pacific still offered passenger service as late as 1965, it used a depot located on Eighth Street. The vacated building was razed in 1965.

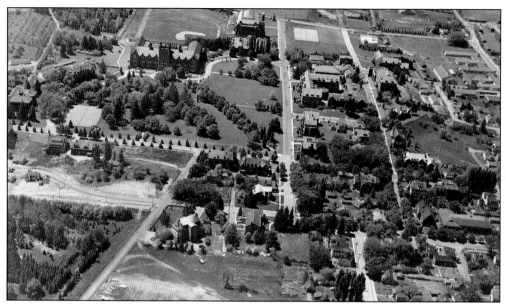

The University of Idaho campus is seen from a bird's-eye view in this 1940s aerial photograph. The legislation creating the University of Idaho was signed on January 30, 1889, before Idaho was even a state. Classes began on October 12, 1892, with not quite 50 students. At that time, the only building on the campus was the partially finished Administration Building, and an important part of the university's curriculum was a preparatory school, which prepared students to enroll as freshmen.

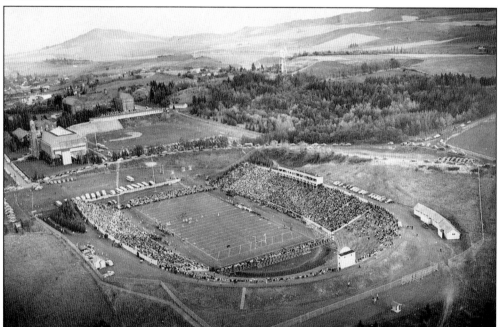

Neale Stadium is the focal point of this aerial photograph taken in the late 1940s. Located on the west end of the University of Idaho campus (where the Kibbie Dome now sits), Neale Stadium was a football field named for university president Mervin G. Neale, 1930–1937. It was destroyed by arson on November 23, 1969, having been condemned the previous year.

Two

AT WORK ON MAIN STREET

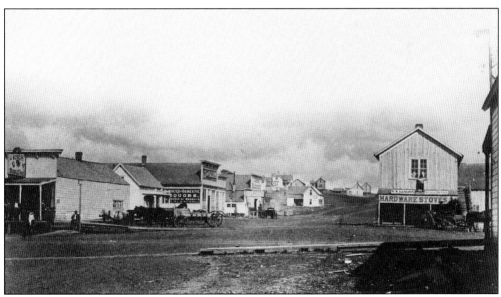

The intersection of Third and Main Streets, *c.* 1880, bears little resemblance to that same intersection today. At far left (now 218 South Main Street) is Gottfried Weber's harness shop, which he established in 1880. The structure served as both shop and home. Note the wooden sidewalks.

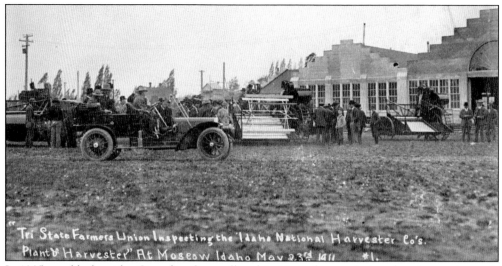

In 1905, two blacksmiths, Cornelius Quesnell and A. N. Anderson, designed an innovative push combine for the harvest of grain. In 1906, a group of Moscow men formed the Idaho National Harvester Company to finance the manufacture of the combine, which became known as the "Little Idaho." The combine sold so well that in 1909 the company expanded and built a plant on north Main Street. The "Little Idaho" was manufactured until 1918.

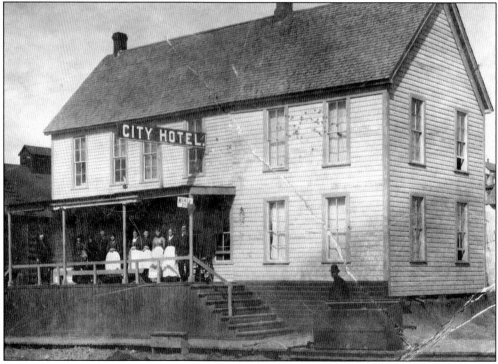

Early Moscow appears to have had more than one City Hotel; the one pictured here in the 1880s was probably located at 112 North Main Street. Another early hotel, also known as the City Hotel, was located on the southeast corner of Main and A Streets; it was advertised as "the best equipped $1 a day house in Moscow." That structure burned in 1890 and was replaced with a three-story, 42-room brick building named the Commercial Hotel.

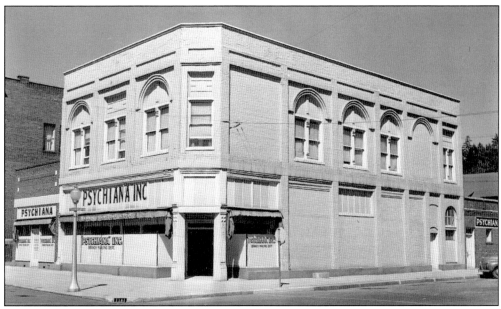

This building on the northeast corner of First and Main Streets housed the accounting and lesson-assembly departments of Frank B. Robinson's Psychiana enterprise. In 1929, pharmacist Frank Robinson established in Moscow the world's first mail-order religion, dubbing it "Psychiana." The building's upstairs housed Moscow's first youth center, which Robinson established.

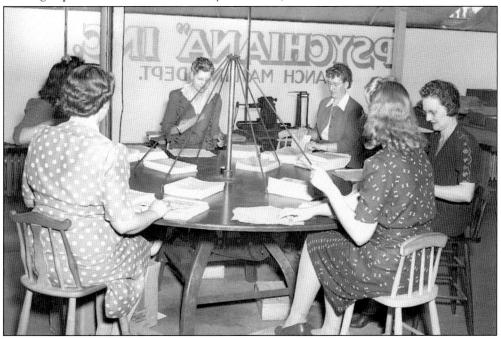

Using a mechanism much like a lazy-susan, Psychiana staff assembly correspondence lessons to be sent to followers of Robinson's unique religion. In return for a fee, students would receive a set of correspondence lessons, written by Robinson, about every two weeks. In his first lesson, Robinson urges his "fellow-students" to study his lessons carefully and to apply the great "Spiritual Law" to their own lives.

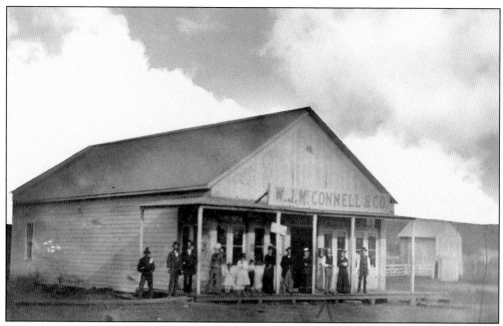

Before becoming Idaho's third governor, William J. McConnell established a general store with partner James H. Maguire on Moscow's south Main Street. The source of this photograph of McConnell and Maguire's early store is a tintype.

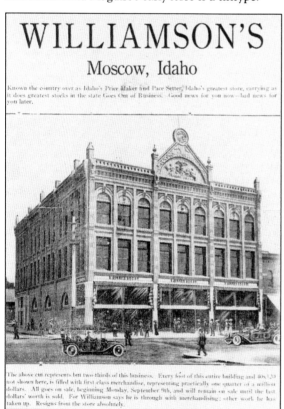

WILLIAMSON'S
Moscow, Idaho

Known the country over as Idaho's Price Maker and Pace Setter, Idaho's greatest store, carrying as it does greatest stocks in the state Goes Out of Business. Good news for you now—bad news for you later.

The above cut represents but two-thirds of this business. Every foot of this entire building and 408,120 not shown here, is filled with first-class merchandise, representing practically one-quarter of a million dollars. All goes on sale, beginning Monday, September 9th, and will remain on sale until the last dollars' worth is sold. For Williamson says he is through with merchandising; other work he has taken up. Resigns from the store absolutely.

In 1891, merchants William McConnell and James Maguire built an impressive brick building at 102 South Main Street to house their retail store. Unfortunately, their business failed during the Panic of 1893, and the building was nearly vacant until Nathaniel Williamson leased it in 1911 to house his general store. Williamson closed the doors of his store in 1919.

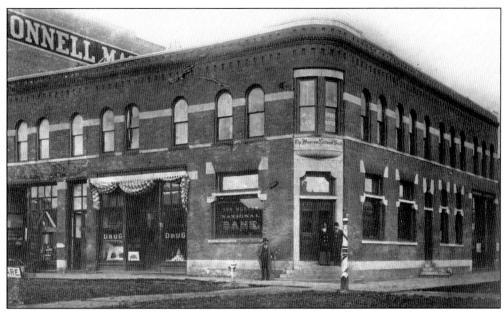

In 1890 and 1891, banker Robert S. Browne built the two buildings located on South Main Street that comprise the Browne Block. The southern building was built in 1891 to house the Moscow National Bank, which Browne founded that year. This bank failed in 1897 and was eventually replaced in this location by the Moscow State Bank, which failed in the 1930s.

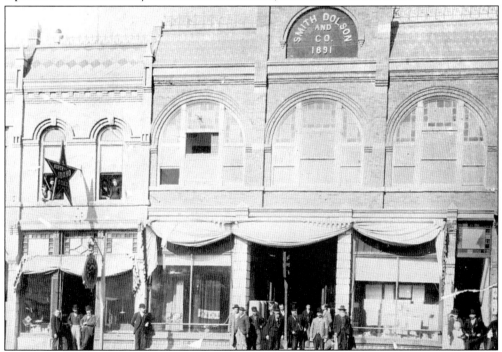

Charles S. Smith and Charles H. Dolson constructed the building that bears their name at 211 South Main Street in 1891 to house their general store. In 1896, the building became the location of a dry goods store known as the Chicago Store, operated by George Creighton and Foster Hall. Eventually Creighton changed the name of the store to Creighton's.

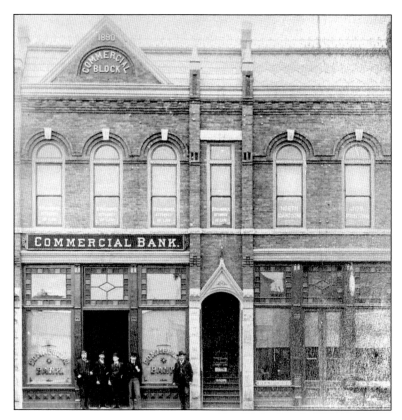

Perhaps Isaac C. Hattabaugh is among the gentlemen pictured in front of this building in the 200 block of South Main Street. Hattabaugh was president of the Commercial Bank, with offices in the southern part of the building. Other early occupants included a newspaper, the *Star of Idaho*, and the offices of a druggist, milliner, jeweler, and lawyer.

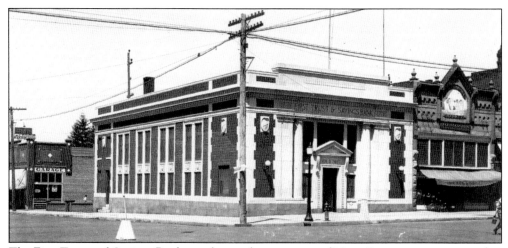

The First Trust and Savings Bank, on the northwest corner of Main Street, was constructed in 1921 and razed in 1964. This location was the site of the Moscow Grocery, operated by Clinton C. Lieuallen, a nephew of one of Moscow's founders, Almon Asbury Lieuallen.

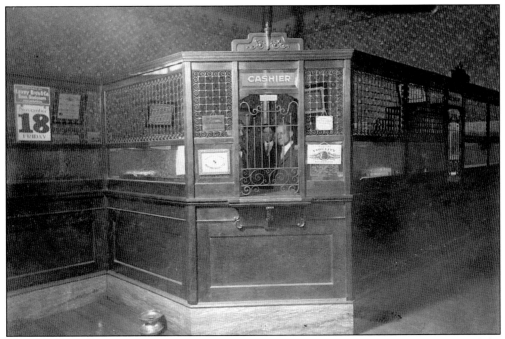

The tellers pictured here could have worked for a number of Moscow banks that occupied the northeast corner of Second and Main Streets during the early decades of the 20th century—the Spokane and Eastern Bank, the First Trust and Savings Bank, or the Moscow National Bank.

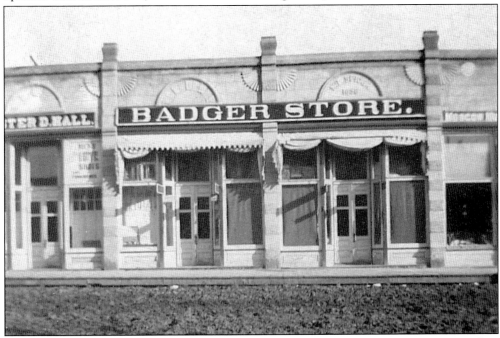

The Badger Store, established by Frank A. David (a native of the badger state, Wisconsin) in 1896, was located in the Spicer Block, which still stands in the 200 block of South Main Street. In 1898, William H. Spicer constructed the building, known for its distinctive sunburst ornaments; the building underwent a major renovation following a fire in the early 1950s.

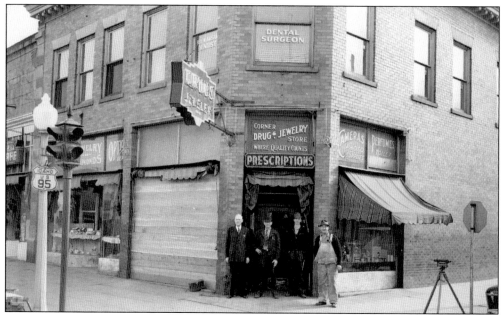

In 1912, the Corner Drug Store became the first occupant of the building George Creighton constructed in 1909 on the former site of Gottfried Weber's harness shop and Joe Niederstadt's brewery at 218 South Main Street. Partners Albert Lindquist and Charles Bolles ran the Corner Drug Store until 1919 when Bolles purchased full interest in the store. In over 50 years as a pharmacist, Bolles never missed a full day's work.

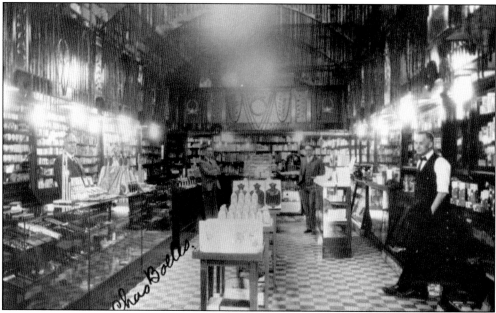

Pictured here is this late-1920s photograph is the interior of the Corner Drug Store at 218 South Main Street. On the left is owner Charles Bolles and to the right is Bolles's employee, Frank Robinson. The identity of the man in the middle is unknown. Robinson, who would go on to found a mail-order religion known as Psychiana in 1929, arrived in Moscow with his wife, Pearl, in 1928.

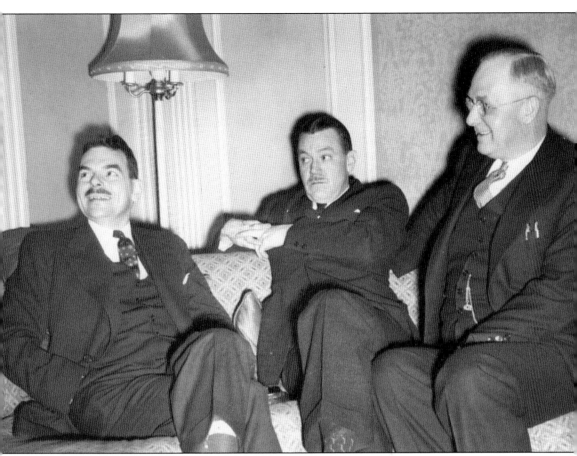

Psychiana founder Frank Robinson (far right) is pictured here with politician Thomas E. Dewey in 1943. The identity of the man in the middle is unknown. In addition to the correspondence lessons he sent to his followers, Robinson also promoted the principles of Psychiana through national radio broadcasts and lectures on college campuses and in major cities. Robinson died of heart disease on October 19, 1948.

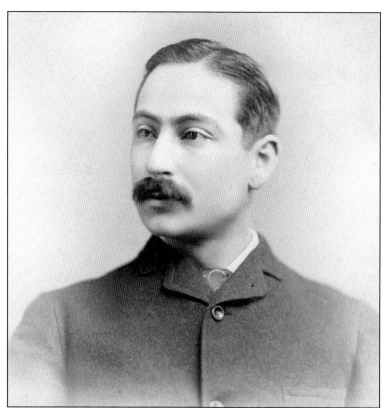

Henry Dernham, pictured here, established the U.S. Wholesale and Retail General Merchandise Store with William Kaufmann in 1889. The building they constructed at 302 South Main Street in 1889 would eventually house Moscow's flagship Main Street business, Davids'.

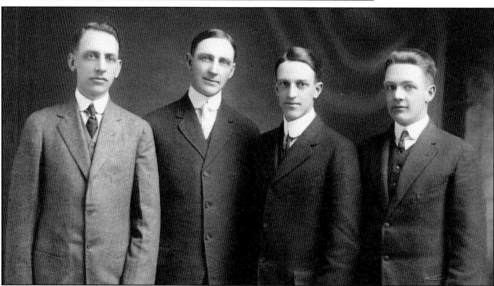

Pictured here in this *c.* 1900 photograph are the sons of Ella and Frank David, one of Moscow's pioneer merchants. From left to right, they are Donald, Howard, Earl, and Homer. In 1899, David, with partner Wellington Ely, purchased the Dernham and Kaufmann building and opened the David and Ely Store. Following Ely's death in 1908, and after sons Homer and Earl joined the firm, David renamed his business, F. A. David and Sons. In 1914, son Howard also joined the business.

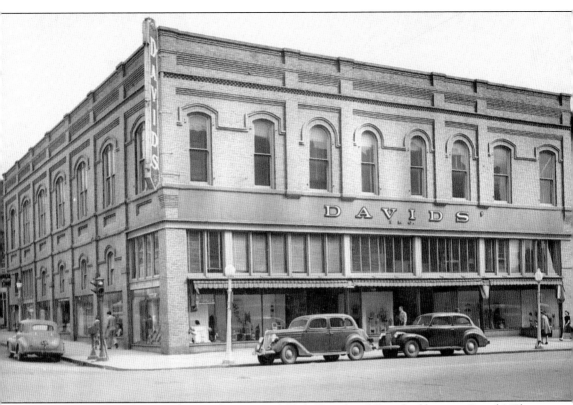

By the time this photograph was taken in 1946, F. A. David and Sons had become Davids'. The store, with three full floors of merchandise, was a department store in the true sense of the term, offering apparel, sporting goods, groceries, and just about everything else in between. The business was sold in 1959 to a businessman from Spokane, Washington.

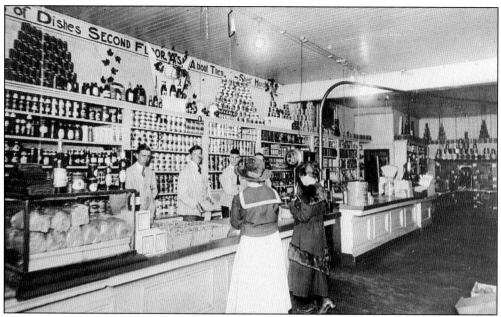

One of the most popular departments of F. A. David and Sons was the grocery department, pictured here in 1918. Two of the clerks are believed to be Mr. Turnbow, far left, and John Sampson, far right. The young woman in front of the counter, to the left, is Clarice Moody Sampson, who recalled in an oral history that the department store would send "a man each morning to your kitchen door to take orders for your groceries." The identity of the other woman is not known.

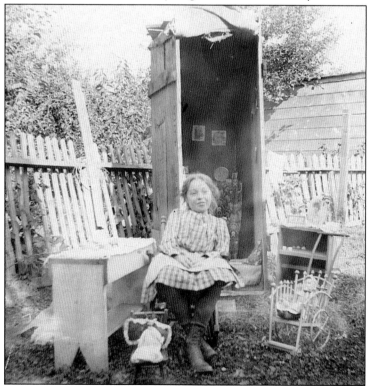

A young Clarice Moody, pictured here in front of the piano box that served as her playhouse, was born in Moscow on January 11, 1894, to George H. and Ida Manning Moody. A lifelong resident of Moscow, Clarice married Harry A. Sampson on April 16, 1919, at the Moody home at 722 Lynn Avenue. According to the newspaper announcement, "the bride was beautifully gowned in pink georgette." She died at the age of 104 in 1998.

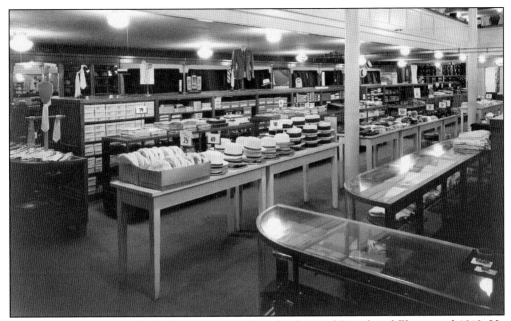

Harry Sampson, husband of Clarice, joined the sales force of David and Ely around 1910. He worked in the men's, boys', and shoe departments and eventually was promoted to head of the men's department, where he stayed until his retirement in 1958. He recalled in an oral history that he "just loved merchandising" and "liked meeting people." He also remembered wearing a mask to avoid influenza contamination while fitting World War I soldiers for their uniforms.

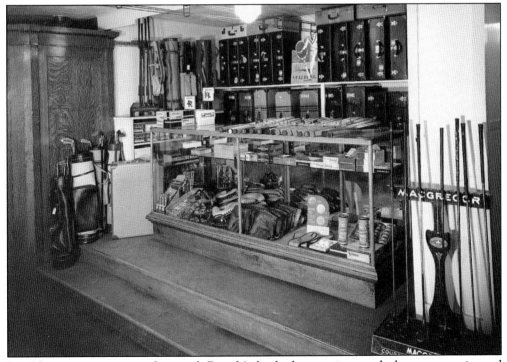

In addition to groceries and apparel, Davids' also had a sporting goods department, pictured here in 1921.

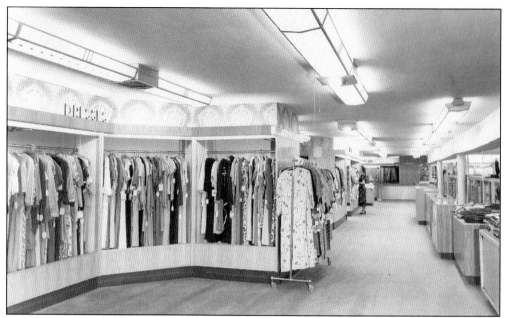

The women's apparel department of Davids' is pictured here around 1940. Longtime Davids' employee Harry Sampson recalled in an oral history that the department store would "supply large farmer families with all the clothing they needed for a year." He recalled that it was "a big deal" for farmers to travel to Moscow because "their own communities, like Genesee or Kendrick, didn't have department stores that could afford comparable inventories."

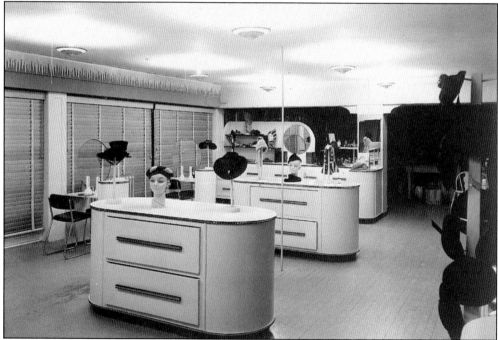

Like husband Harry, Clarice Moody Sampson also worked at Davids' intermittently. For a while, she worked in the millinery department, which was actually a separate department, not owned by Davids'.

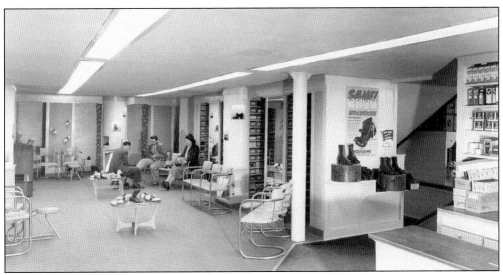

Davids' shoe department, around 1940, offered a full range of footwear, from oxfords to work boots.

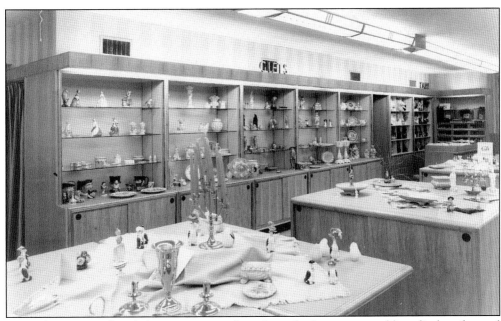

Around 1940, Davids' gift department must have been dazzling in its sparkling display of crystal and silver.

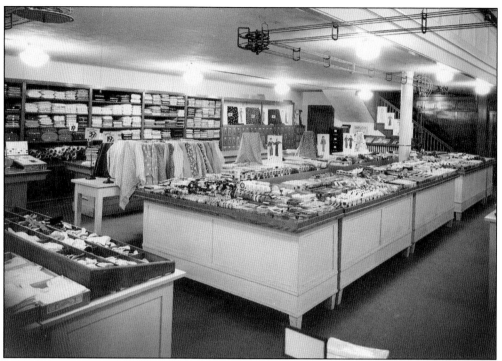

At one time, no respectable department store would have been without a dry goods department, seen here at Davids', c. 1940.

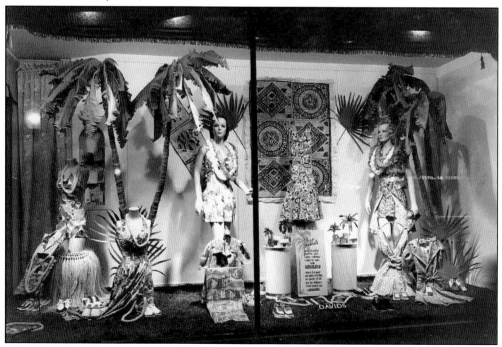

Today large window displays are rare, so this Hawaiian-themed window display is indeed a sight to behold. This display graced the exterior of Moscow's premier department store, Davids', sometime in the 1940s or 1950s.

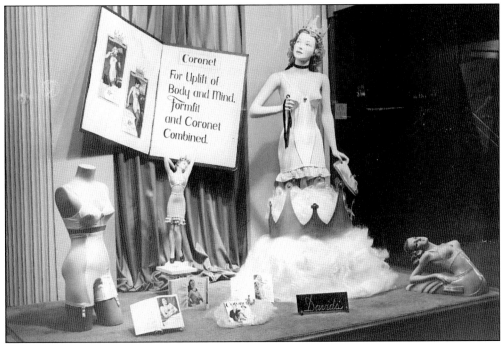

Like all major department stores, Moscow's Davids' sold ladies lingerie, and this c. 1940 window display promotes Coronet-brand foundations with a panache that would be difficult to find today.

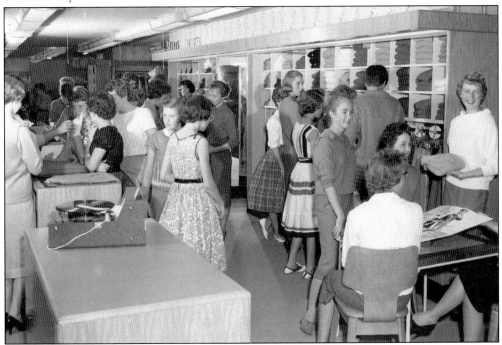

Until 1979, when the David family sold its interest in the store, Davids' was a favorite shopping place for many Moscowans, including the young women pictured in this 1950s photograph. The building that housed Davids' was placed on the National Register of Historic Places in 1979.

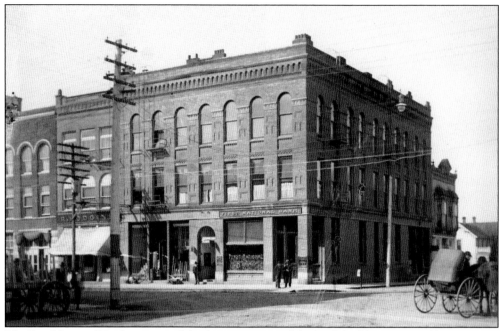

The First National Bank was one of the first occupants of the brick building, pictured here c. 1900, constructed in 1891 at 301 South Main Street. According to a financial statement published in a local newspaper, the assets of the First National Bank on March 17, 1919, totaled $875,500.

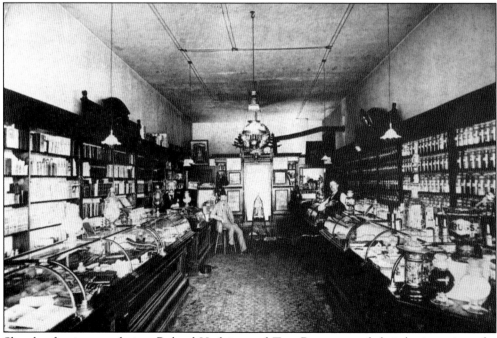

Shortly after its completion, Roland Hodgins and Tom Reese moved their business into the building constructed by George B. Hovenden at 307 South Main Street. Hodgins Drug Store, pictured here on June 23, 1892, has been continuously in business in this location ever since.

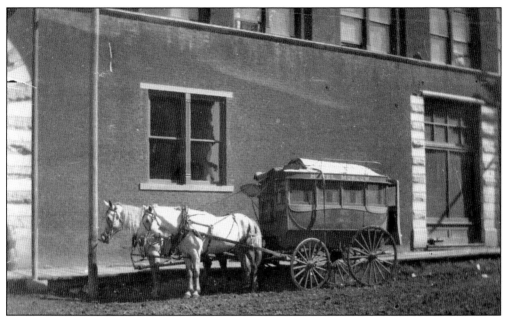

Moscow's Main Street was not paved until 1912, so this photograph of the Hotel Moscow's stagecoach was taken sometime before then. Located at 313 South Main Street, in a building he constructed in 1891, Robert H. Barton established the Hotel Moscow following a fire that destroyed his first hotel on this site. The Hotel Moscow building was placed on the National Register of Historic Places in 1978 and is still in use today.

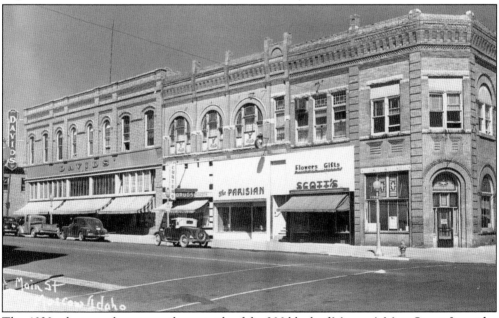

This 1930s photograph captures the east side of the 300 block of Moscow's Main Street. Leonidas B. McCartor constructed the McCartor Block in two sections, north and south, in 1891. Occupants of the south building included the undertaking business of Grice and Son, a movie house, and a dress shop. Businesses occupying the north building included the Farmers Bank and a jewelry store.

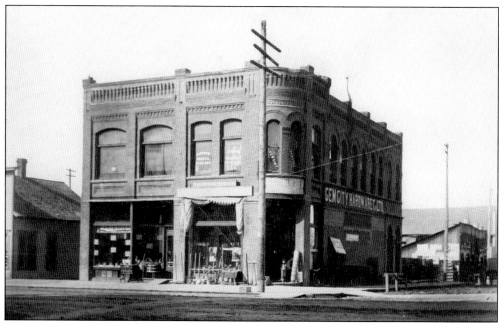

Farmer Kenneth Oliver Skattaboe built the Skattaboe Block at 401 South Main Street in 1891. Early tenants included George Creighton's Chicago Store, Gem City Hardware, Hutchinson Photo Studio, and until recently, the telephone company. This building was placed on the National Register of Historic Places in 1978 and is in use today as a private school.

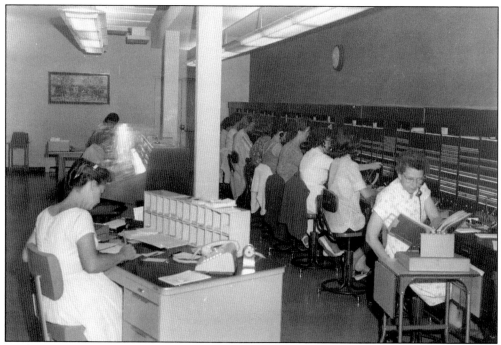

Employees of General Telephone and Electric are pictured in this 1950s photograph. The telephone company purchased the Skattaboe building in the 1920s and, in 1927, extended it west to house its telegraph service and the telephone exchange.

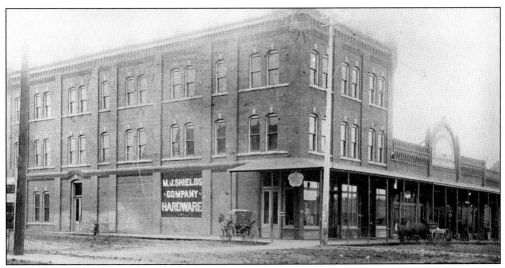

Michael J. Shields constructed the first three-story brick building in Moscow in 1889. Located in the 400 block of South Main Street, the building was also the first to have a freight elevator. Shields, one of Moscow's most successful businessmen, also operated a sawmill, sheet metal and plumbing shop, and a construction business.

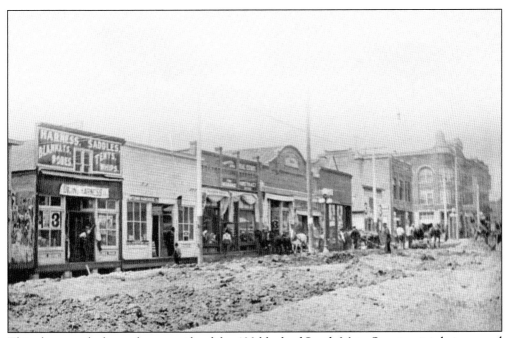

This photograph shows the west side of the 400 block of South Main Street as it is being paved in 1912. At the far right is the Hotel Moscow, and the building with the curved top in the middle of the photograph is the Holt Building. Stockman Charles B. Holt constructed this building in 1903 to house his butcher shop.

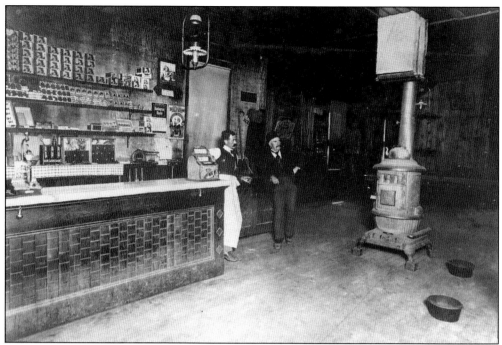

According to information on the back of this c. 1900 photograph of Blanchard's Cigar Store, the men pictured here are George and Charles Blanchard. The Cigar Store, established by Charles's father, John, was a popular gathering place for Moscow men until the late 1940s.

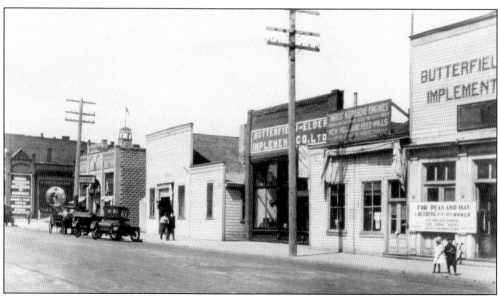

About 1902, Charles L. Butterfield arrived in Moscow from Wisconsin and soon bought into a farm-implement business established by D. S. and C. S. Elder. The business was located at 520 South Main Street, and while the Elders eventually sold their interests, Butterfield continued in business at this location until 1930.

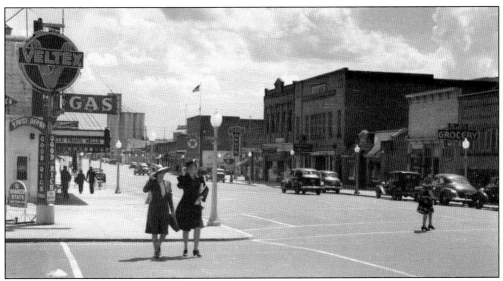

One of the most interesting buildings in this *c.* 1944 photograph of the west side of the 500 block of Main Street is the one at 521 South Main. It is a one-story, yellow brick building with a large central arched entrance and a red tile roof. It has served as the photograph studio of John J. Sterner and, later, as a tavern. Today it houses one of Moscow's downtown anchor businesses, Book People, owned and operated by Robert Greene.

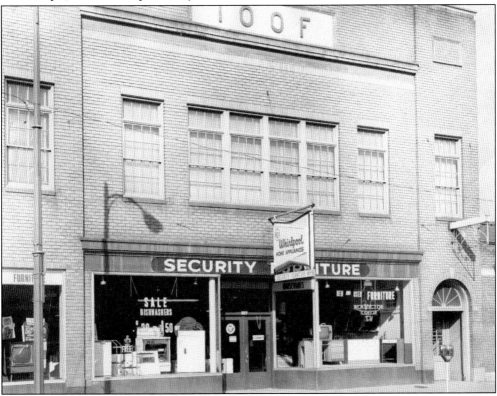

The IOOF on the surface of this building stands for Independent Order of Odd Fellows, a fraternal organization that was established in Moscow in 1889. This building was erected in 1926.

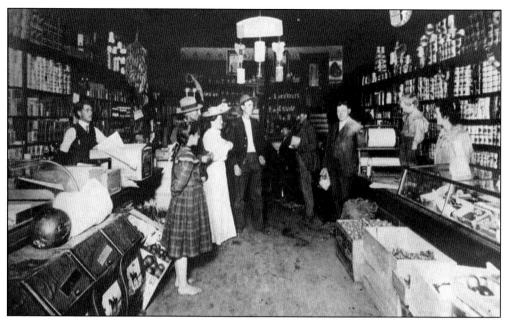

Carssow's Grocery Store operated in Moscow at 616 South Main Street until about 1912. The identities of the people in this *c.* 1900 photograph are unknown. In an oral history, Clarice Moody Sampson recalled that Mr. Carssow would "get in fruit and watermelons and things that came in hay wagons from Juliaetta and Lewiston . . . everybody in Moscow would go down and get their fruit."

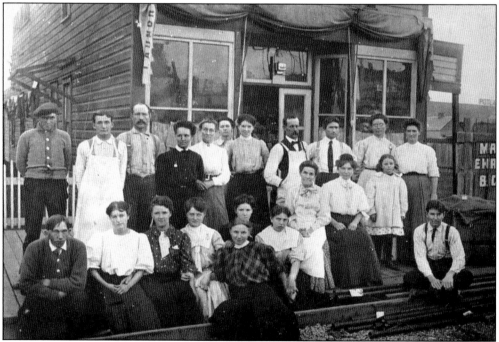

At 623 South Main Street, Charles B. Green began the Moscow Steam Laundry in 1896. According to Lillian Otness in *A Great Good Country*, Green's motto was "We clean everything—your character excepted." The identities of the people in this *c.* 1900 photograph are unknown.

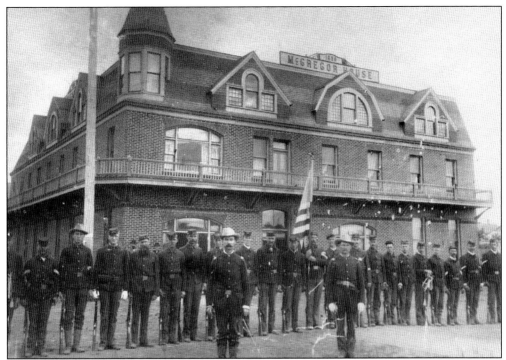

Henry McGregor built a hotel he called the McGregor House at 710 South Main Street in 1890. The identities of the men in this c. 1890 photograph are unknown, as is the purpose of their assembly. Around 1893, physicians Charles L. Gritman and R. C. Coffey bought the McGregor House and converted it into a private hospital.

The focal point of this 1944 photograph, taken by Moscow photographer Charles Dimond, is Gritman Hospital, now Gritman Medical Center. In 1937, following the death of Charles Gritman in 1933, a group of Moscow citizens formed the Moscow Hospital Association. The association purchased Gritman's hospital and raised the funds for a new hospital building, which was constructed on the site of the old building between 1938 and 1941.

In 1944, Moscow photographer Charles Dimond took a series of photographs of Moscow's commercial district. Pictured here is the west side of the 600 block of Main Street with the storefront of the Moscow Steam Laundry, a focal point. The laundry also offered dry-cleaning services.

Charles Dimond's camera captures the intersection of Sixth and Jackson Streets in 1944. Note the soldiers and sailors strolling along the north side of Sixth Street. The building on the hill in the center background of this photograph is the Latah County Courthouse, erected in 1888 after approval of a $20,000 bond issue.

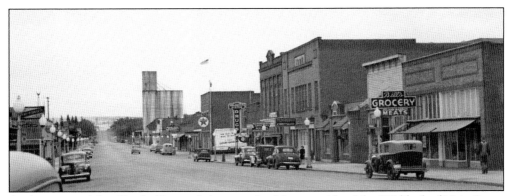

At the center of this Charles Dimond photograph of the west side of the 500 block of Main Street is the building constructed to house Moscow's Masonic lodge. The pediment of this building, built in 1911 and still in use today, bears the Masonic emblem. Note the grain towers of the Latah County Grain Growers in the background.

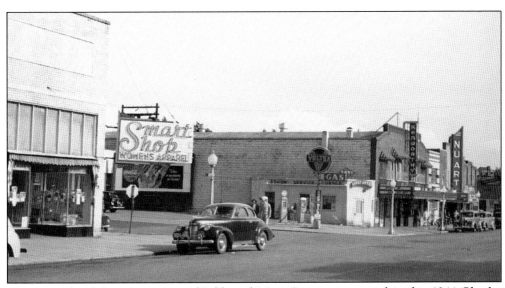

The east side of the intersection of Fifth and Main Streets is pictured in this 1944 Charles Dimond photograph. At far right are Moscow's downtown movie theatres, the Kenworthy and the NuArt, built by Milton Kenworthy in 1926 and 1935, respectively. Both theatres were placed on the National Register of Historic Places in 2001.

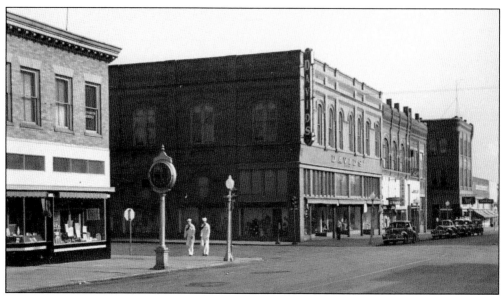

With its striking composition, this 1944 photograph by Charles Dimond is as much art as history. While the focal point of the photograph is the Davids' building at the intersection of Third and Main Streets (looking east), the two sailors sandwiched between the streetlight and the clock certainly catch the viewer's attention.

This 1944 Charles Dimond photograph of the intersection at Third and Main Streets, looking west, is notable documentation of a street scene that no longer exists. The building on the far right, which housed a bank, no longer stands, though the location is now the site of another bank building. Also gone is the building in the center of this photograph; in its place is a parking lot.

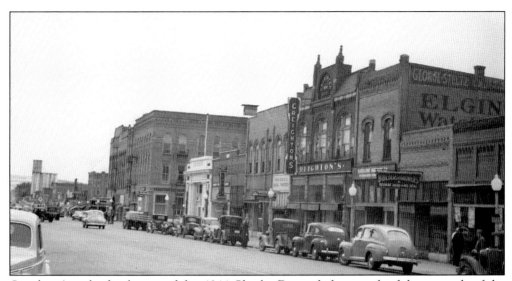

Creighton's is the focal point of this 1944 Charles Dimond photograph of the west side of the 200 block on Main Street. For many years, George Creighton ran a dry goods store in Moscow. Longtime Moscow resident Clarice Moody Sampson recalled in an oral history that her parents traded at Creighton's for dry goods and at Davids' for groceries. She also recalled that Creighton visited Ireland every year to buy linen.

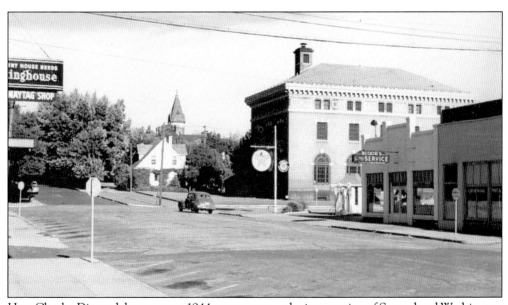

Here Charles Dimond documents a 1944 street scene—the intersection of Second and Washington Streets—that is little different today. The focal point of this photograph is the federal building in the background. Today this building houses Moscow's city hall.

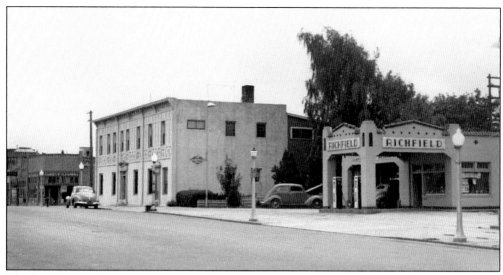

The building on the right, the Richfield service station, no longer exists, but the building on the left, the Moscow Manor, remains in use today. This location, 103 North Main, was the site of Moscow's first brick hotel, the Hotel Del Norte. Around 1920, Clyde E. Witter converted the structure into apartments.

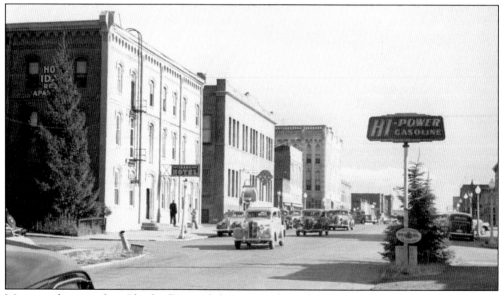

Moscow photographer Charles Dimond documented two buildings in the 100 block of North Main Street in this 1944 photograph. On the left is the Hotel Idaho, which was razed in 1977 to make way for a highway couplet. Next door is the Elks Temple, built in 1905 by the oldest Elks lodge in the state of Idaho. This building now houses a nightclub.

Three

AT WORK
AROUND TOWN

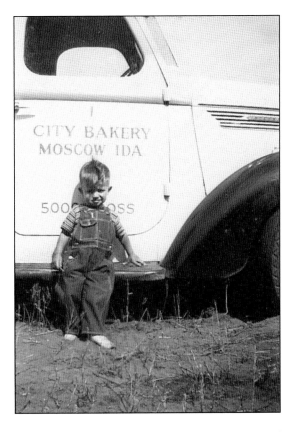

Three-year-old Gary Bryan, now professor emeritus with the veterinary faculty of Washington State University in nearby Pullman, Washington, poses in front of a delivery truck for the City Bakery. According to an advertisement for the bakery, which was probably located on the south side of Third Street between Washington and Main Streets, in the 1915 Moscow High School yearbook, the bakery offered "the best cup of coffee and lunches to go." Bryan's wife is Nancy Chaney, current mayor of Moscow.

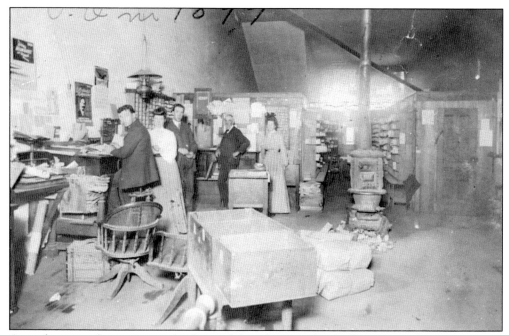

According to information on the front of this photograph, the location is the Moscow Post Office and the date is 1894. While Moscow's first post office was located near the intersection of Mountain View and Hillcrest Streets, the location of the post office pictured in this photograph is unknown, but it was probably in one of the buildings on Main Street.

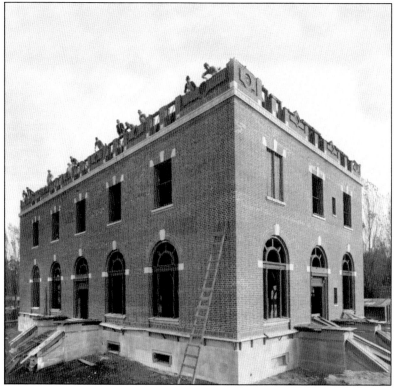

Moscow's first federal building was constructed on the northeast corner of Third and Washington Streets in 1911. This building housed Moscow's post office for over six decades. A new federal building was constructed between Fourth and Fifth Streets in 1974. Note the workmen peering over the top of the building.

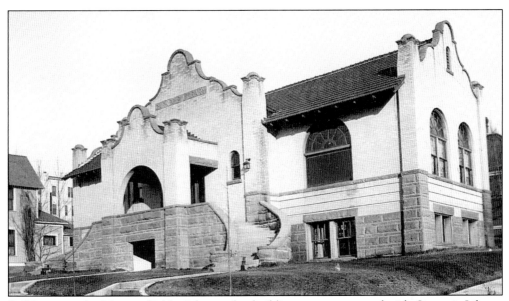

Still home to the Moscow Public Library, this building was constructed with Carnegie Library Endowment funds in 1906 because of the efforts of two Moscow women's groups, the Moscow Historical Club and the Pleiades. An addition to the north of this building, which is on the National Register of Historic Places, was opened in 1983.

Pictured here is Latah County's first courthouse, c. 1890, located on Fifth and Adams Streets. It was built in 1889 and was replaced by the structure currently occupying the site in 1958.

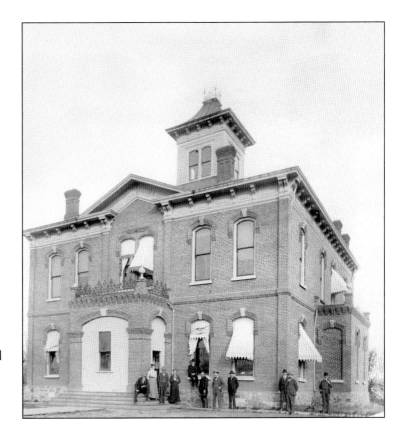

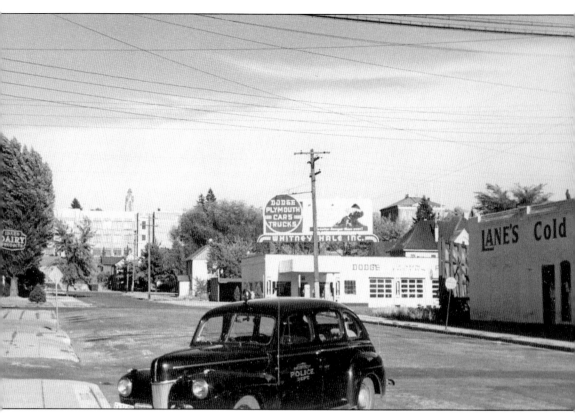

In the foreground of this 1944 Charles Dimond photograph of Fourth Street is the police station of the Moscow Police Department. Although not in the same building, the "cop shop" remains on Fourth Street today. In the background of this photograph is the Moscow High School building, constructed in the 1930s.

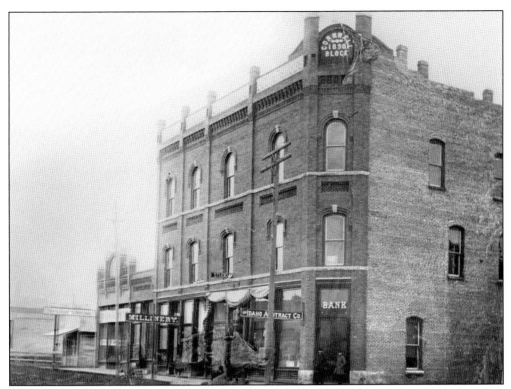

In 1890, financier Mason Cornwall erected a three-story brick building in the 100 block of East Third Street. One of the businesses occupying the building was Cornwall's bank, the Bank of Moscow. Another was the Casino, a movie theatre that, according to Lillian Otness in *A Great Good Country*, offered children a free ice cream cone when they went in to see the movie.

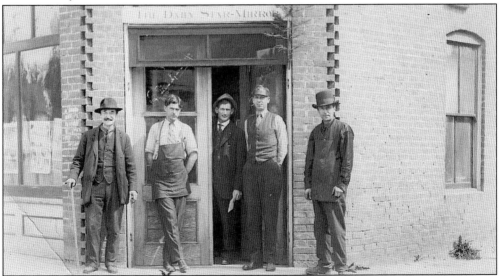

The *Daily Star-Mirror* started rolling off the presses on September 28, 1911. It is likely that the newspaper, which touted itself as providing "a complete record of Moscow's day in your home soon after the news occurs," was located in the Clough Building in the 200 block of East Third Street. Brick maker Fred S. Clough constructed this building in 1888.

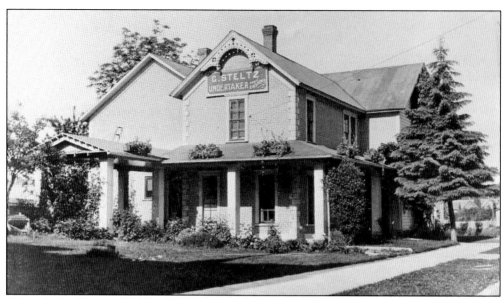

Before the building at 129 West Third Street, pictured in this c. 1900 photograph, housed George Steltz's funeral service, it was a boardinghouse operated by Jimmy Johnson and his wife. According to Homer David in his recollections of early Moscow, Johnson was a "large, rotund man, a genial character . . . who let Mrs. Johnson run the establishment." This building was replaced by one Frank Robinson constructed to house his Psychiana operations.

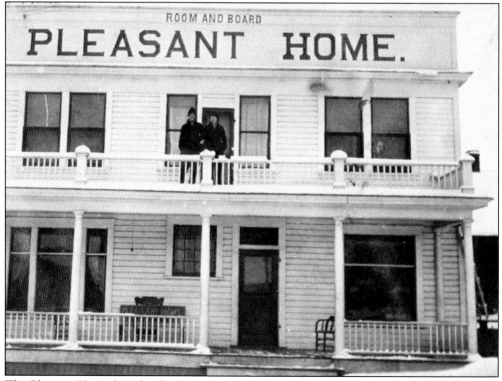

The Pleasant Home boardinghouse, operated by the Gallup family, was located at 213 South Jackson Street. The building was operated as a rooming house until 1935.

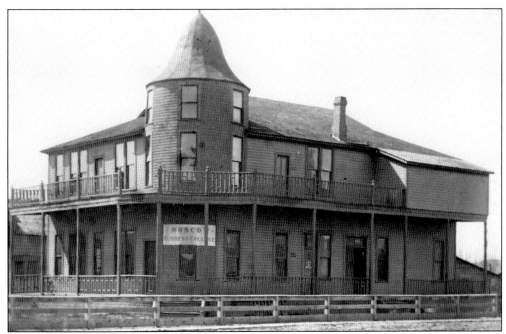

The building pictured in this c. 1900 photograph, located on the southwest corner of First and Jackson Streets, has served many purposes during the past decades. In 1892, it housed the Moscow Businessmen's Club; in 1896, the Elks; then the Moscow Business College, and by 1908, the Inland Empire Hospital, operated by Dr. Warner H. Carithers. Today it is an apartment house.

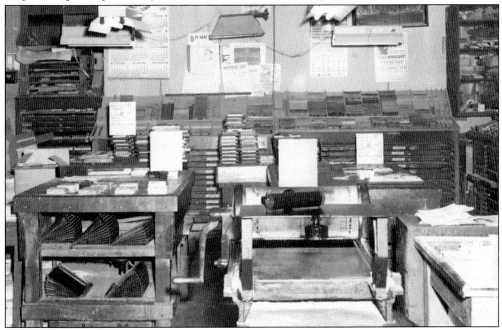

This 1949 photograph documents the interior operations of Moscow's longest-running newspaper, the *Daily Idahonian*, now the *Moscow-Pullman Daily News*, which is located on Jackson Street. According to Bert Cross in his history of Moscow newspapers, no one seems to know where the name came from or why the "n" was inserted into "Idahonian."

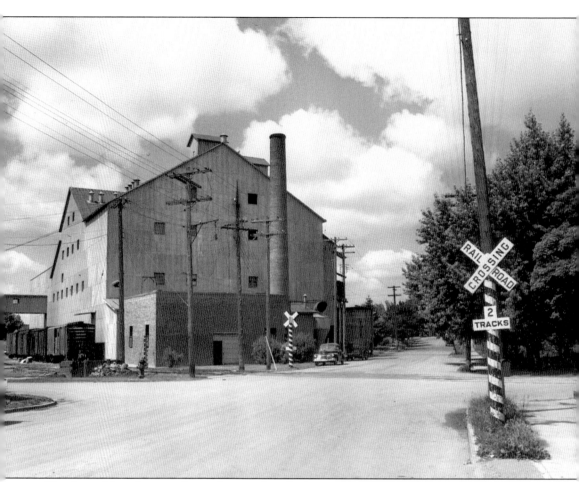

The date of this photograph is unknown, but the location is the intersection of A and Almon Streets. The building shown here is the Washburn-Wilson Seed Company plant, the first company on the Palouse to process peas. Herman N. Wilson and his father-in-law Melvin Washburn started the company in 1916; the mill was expanded after World War I and rebuilt after a mid-1940s fire. In his 1946 obituary, Wilson was described as the "dean of the nation's pea industry."

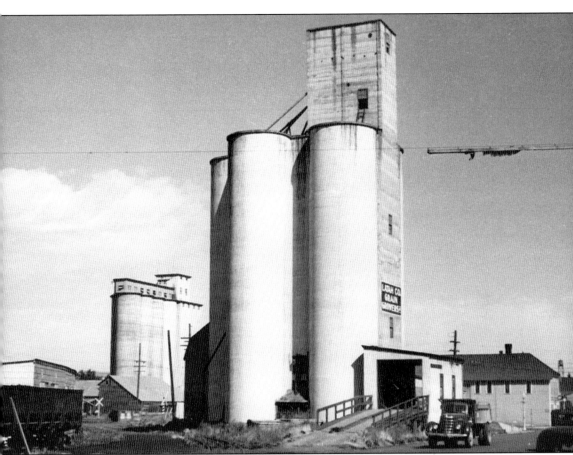

Moscow photographer Charles Dimond captures the majesty of Moscow's Sixth Street grain elevators in 1944. Built between 1885 and 1954, the elevators are still standing today. Historian Lillian Otness described these elevators as "perhaps the most interesting group of grain storage structures in the State," in her book *A Great Good Country*.

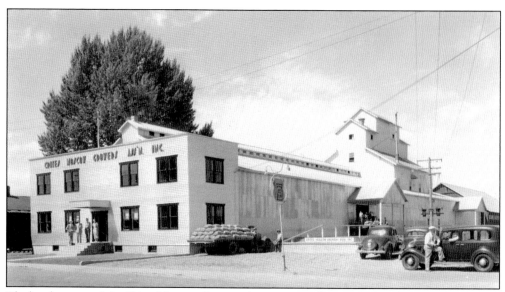

The headquarters of the Crites-Moscow Growers Association is documented in this 1944 photograph. Located on Eighth Street, this pea seed processing company is still in operation today. Willis L. Crites managed the operations for many years. He died in May 1941.

Following the death of Willis Crites, Merl W. Stubbs, pictured here during the 1940s, became manager of the Crites-Moscow Growers Association. Stubbs, who was succeeded by W. Homer Peterson in 1950, served as chair of the Moscow School Board in 1959.

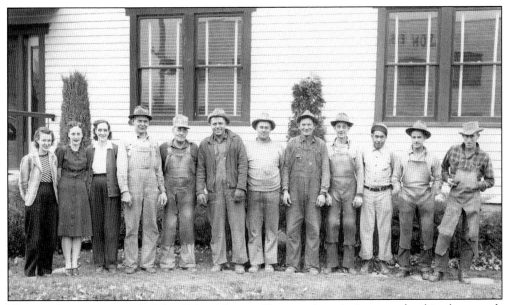

The warehouse personnel of the Crites-Moscow Growers Association pose for this photograph sometime in the 1940s. Information on the back of the photograph provides first names only. From left to right, they are Hazel, Esther, Helen, Ted, Jim, Art, Sie, John, Bill, Gene, Roy, and Elmer. "Helen" is Helen Woolfe, who worked for the company for over 30 years. "Roy" is Roy Harris, who worked at Crites for nearly 30 years. "Gene" is Eugene Settle, whose family was one of the few African American families to settle in Latah County during its early days.

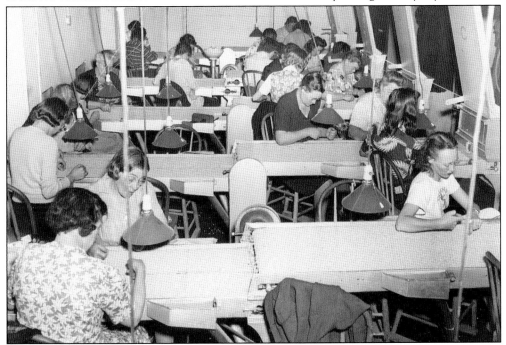

Before the invention of sorting machines, pea seeds were sorted by hand; this photograph documents a handpicking crew at the Crites-Moscow seed company sometime in the 1940s. Longtime Crites employee Helen Woolfe began her career with the company as a hand picker.

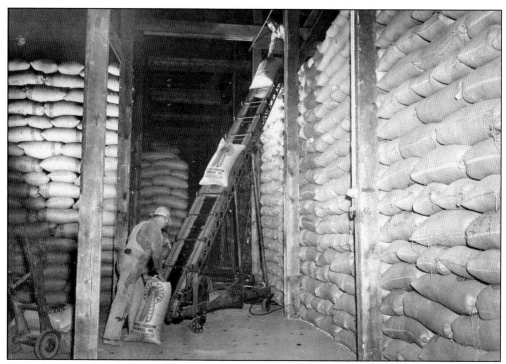

Crites-Moscow warehouse workers Roy Harris and Sie (last name unknown) pile bags of seed sometime in the 1940s.

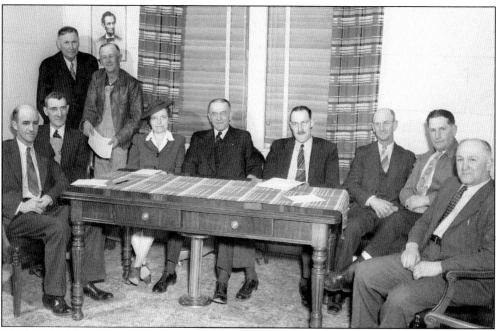

The board of directors for the Crites-Moscow Growers Association is photographed sometime in the 1940s. The woman pictured here is Pauline Crites, widow of Willis Crites, and next to her is farmer Fred Hagedorn, whose family has been associated with Crites for decades. Fred's son Gerry Hagedorn served as president of the Crites Board of Directors in the 1970s.

Four

AT HOME AND
AT WORSHIP

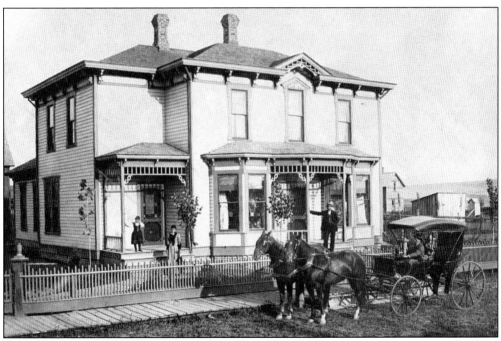

Pictured here in 1893, the John Paulson home at 804 South Washington Street was razed in 1973 to make room for a medical building. John is the fellow on the steps in front of the house, his wife, Jennie, stands next to the tree in the yard, their daughter Mabel is on the left porch, and son Elmer is in the buggy. In 1919, Elmer was named a member of the Latah County Victory Loan Drive Committee, which rallied people to buy war bonds to support the nation's efforts during World War I. He died in August 1959.

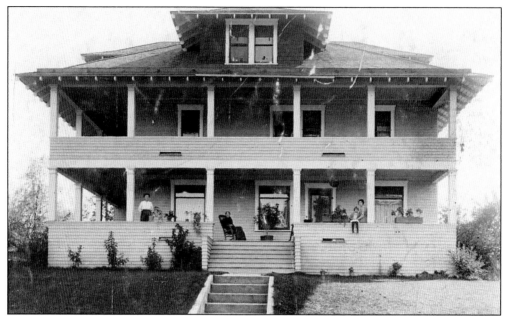

Emma Edmundson and her family ran a rooming house in the structure pictured here around 1912. Located at 425 East Third Street, this house is in use today as an apartment building. Emma's son Clarence "Hec" Edmundson, former track star and coach for the University of Idaho Vandals, was named track coach at the University of Washington in May 1919. A stadium bearing his name now stands on the UW campus.

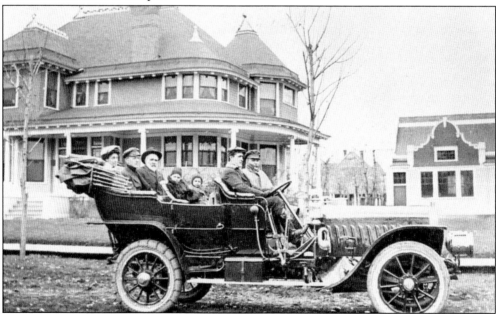

The Day Mansion, pictured here in 1914, reveals Moscow's place in the history of northern Idaho. A member of the family that became wealthy after discovering silver in the Coeur d'Alene mining district, Day built this fine home in 1904 shortly after marrying a Moscow girl, Lucy Mix, the daughter of Mary and Franklin E. Mix. Located at 430 East A Street, the house is now occupied by the Tim and Deena Kinkeade family.

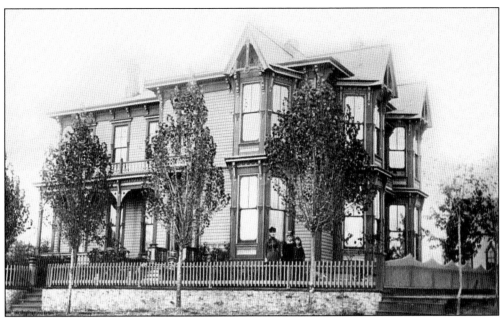

In 1886, William J. McConnell built this structure, pictured in the 1890s, at 110 South Adams Street shortly after arriving in Moscow and establishing a general merchandise store. McConnell's wife, Louisa, and their daughters stand in front of the house. In an oral history, longtime Moscow resident Ione Adair recalled that Mrs. McConnell was a "timid, shy person" who remained in Moscow when her husband left for Boise to assume the governorship.

For several years, the Adair family occupied what is now known as the McConnell Mansion. Dr. William A. Adair was an early Latah County physician, and his 1902 prescription for a member of Moscow's Lieuallen family is pictured here. The mansion was placed on the National Register of Historic Places in 1974.

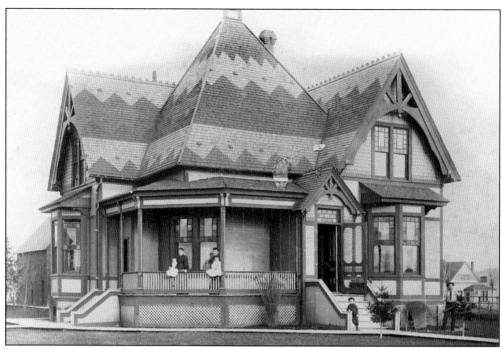

Located at 411 East B Street, the home pictured in this *c.* 1900 photograph was built for the William Baker family in 1886. The Bakers eventually left Moscow, and in 1890 businessman William J. Shields purchased the home.

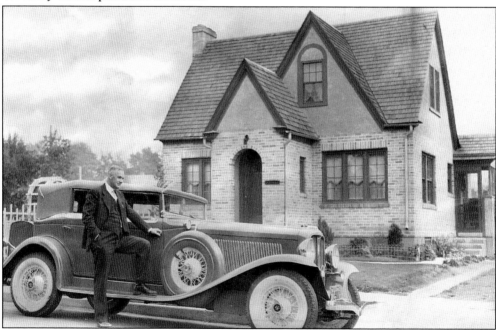

Built in 1934, the Frank B. Robinson home at 122 South Howard Street was extensively remodeled in 1938. Robinson, founder of Psychiana, was particularly fond of cars, and a Spokane, Washington, newspaper reported in 1934 that he had recently purchased a handmade Deusenberg, the "fastest and most powerful car in the entire northwest."

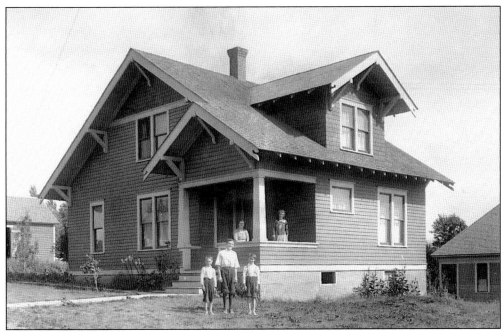

The O. Charles Carssow family occupied the home located on the corner of Spotswood and Harrison Streets, pictured here *c.* 1900. Carssow operated a grocery store on Moscow's Main Street from 1895 to 1912, and his wife, Belle Estes Carssow, worked as a reporter for a local newspaper, the *Star-Mirror.*

Now on the National Register of Historic Places and owned by Nils and Joyce Reese, the home seen in this *c.* 1900 photograph was built by financer Mason A. Cornwall in 1889. According to Lillian Otness in *A Great Good Country,* the location of the cupola on top of the house, rather than over the entrance, is the result of an error in construction.

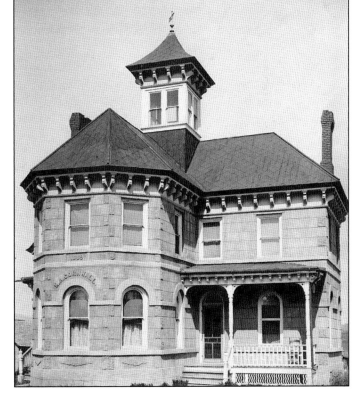

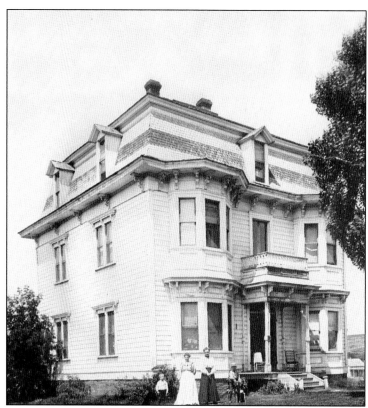

When it was built in 1884, the Almon Asbury Lieuallen home was located in the middle of a wheat field, and Lieuallen left the structure's top floor unfinished so that his children and their friends could use it as a roller-skating rink. The house was placed on the National Register of Historic Places in 1978 and is now used as an apartment building.

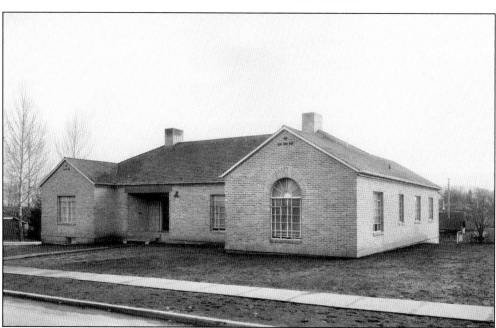

In 1937, pharmacist Charles O. Bolles built this house, located on B Street, for his family. In an undated note found among photographs of the Bolles home, now in the archives of the Latah County Historical Society, Bolles explains that the room with the arched window is the den.

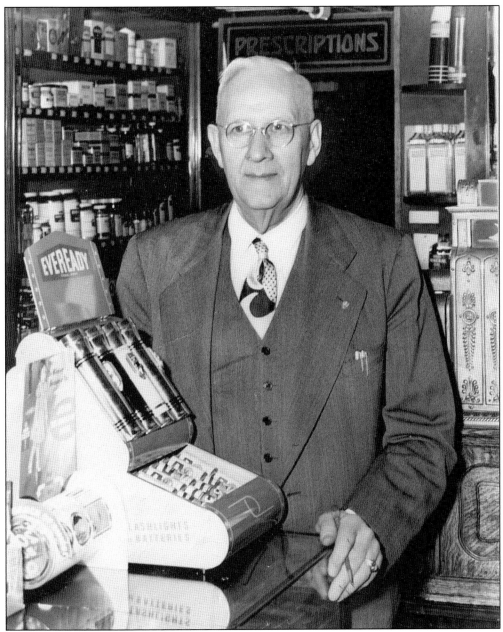

Pictured here around 1950, Charles Bolles, owner of the distinctive brick home on Moscow's B Street, was a longtime resident and businessman who owned the Corner Drug and Jewelry Store on Main Street. According to an advertisement for his store in a 1931 collection of recipes from the Presbyterian Ladies Aid, a wide variety of gifts were available "for every occasion," as were such "quality lines" as Holmes and Edwards, Fostoria Glassware, and Whitman's Chocolates. Bolles died in 1955.

Marguerite Bolles, wife of Charles Bolles, is pictured here around 1939. She died in September 1968.

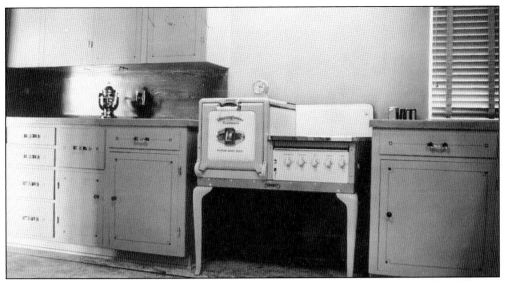

The interior of private homes were rarely photographed and are seldom found in the collection at the Latah County Historical Society. This photograph documents the kitchen of the Charles and Marguerite Bolles family around 1939.

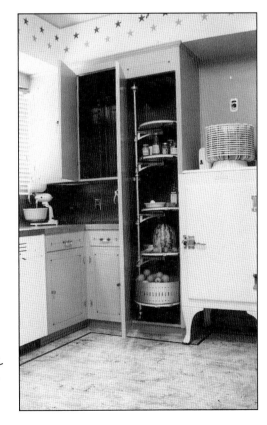

The c. 1939 refrigerator in the kitchen of the Charles and Marguerite Bolles family resembles early General Electric models. According to a 1933 advertisement for GE all-steel refrigerators, "Fortune—good fortune—awaits the woman who chooses a General Electric Refrigerator!"

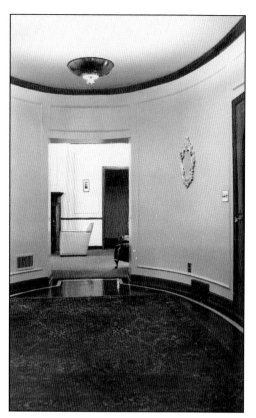

In an undated note found among photographs of the Bolles home, now in the archives of the Latah County Historical Society, Charles Bolles describes the foyer of his home: "Of course, [the] entrance hall is in the middle. Back of the entrance hall is the powder room and lavatory." This photograph was taken around 1939.

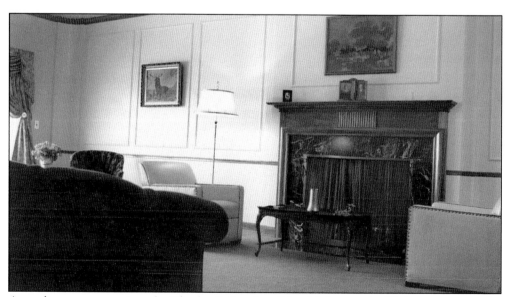

According to notes written by Charles Bolles describing his home, the "living room runs the length of the house." This photograph was taken c. 1939.

In 1950, University of Idaho engineering professor William Parish and his colleagues began the construction of his family's home in Moscow's first suburb, University Heights. Parish and friends poured the foundation and built the house themselves. Bill and his wife, McGee, still reside in this home. (Courtesy of Bill and Magee Parish.)

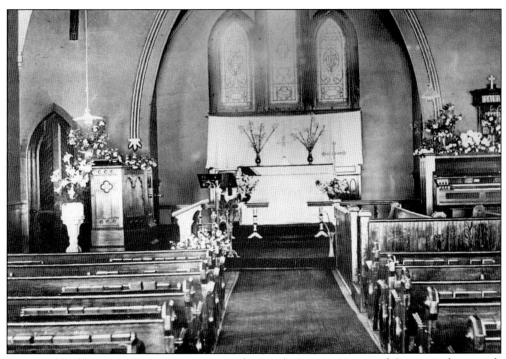

Images of building interiors are rare among the Latah County Historical Society's photograph collection, so this image of St. Mark's Episcopal Church at the turn of the 20th century is indeed a treat. Moscow's Episcopalian congregation was organized in 1888, and its first church built in 1892 on the southwest corner of First and Jefferson Streets.

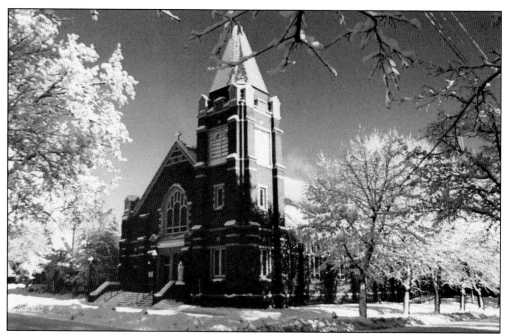

Edward Kelley, the bishop of the Diocese of Boise, dedicated St. Mary's Catholic Church on Polk Street on December 14, 1930. The *Spokesman Review*, a Spokane, Washington, newspaper, reported that the construction costs of the church totaled $37,000. This building remains the home of St. Mary's Parish today.

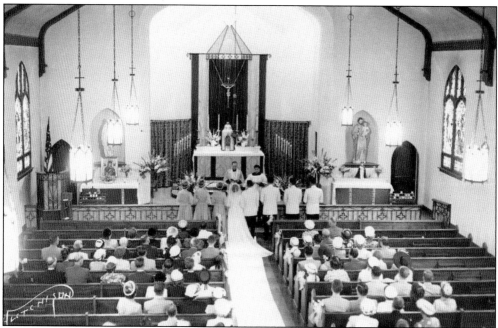

This *c*. 1940 photograph taken by a photographer from Moscow's Hutchinson Photo Studio is probably the interior of St. Mary's Catholic Church. According to an October 24, 1948, parish bulletin, no confessions would be heard on Saturday afternoon October 30 because of the Idaho-Washington State football game.

One of Moscow's most distinctive architectural landmarks is the Methodist Episcopal Church, located at 322 East Third Street. This National Register property was built in 1904 with native basalt. With a recently remodeled interior, this building today still houses the Methodist congregation.

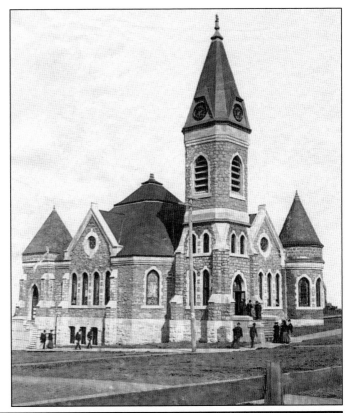

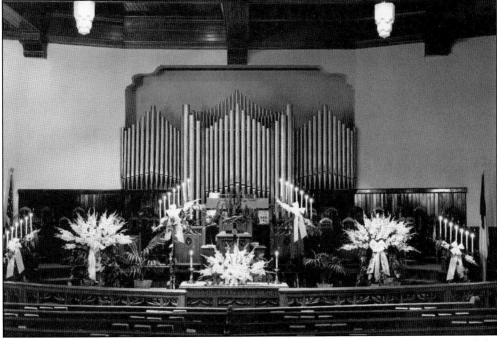

A photographer from Moscow's Hutchinson Photo Studio, taking wedding pictures, captured the interior of the Methodist Episcopal Church sometime in the 1940s.

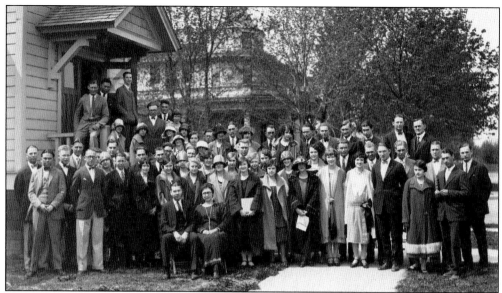

Members of the college group associated with Moscow's First Baptist Church pose for their photograph sometime in the 1930s in front of the congreation's church on the southeast corner of First and Jackson Streets. This location also was the site of Moscow's first church building, now long gone. The original structure was completed in 1881 to house members of the Zion Baptist congregation.

Because information on the back of this c. 1930 photograph identifies this as the Lutheran Church on Second Street, the people pictured here are probably members of the Swedish Lutheran congregation. According to local historian Lillian Otness, "For many years the Swedish and Norwegian Lutherans maintained separate churches, so that services and instruction could be conducted in the native languages of the members."

Five

AT PLAY AND IN FELLOWSHIP

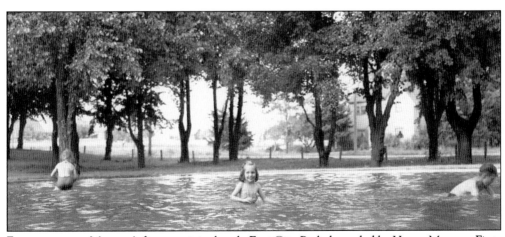

For many years, Moscow's first municipal park, East City Park, bounded by Hayes, Monroe, First, and Third Streets, included a wading pool, which the children of John and Jeanette Talbott enjoy sometime in the 1940s.

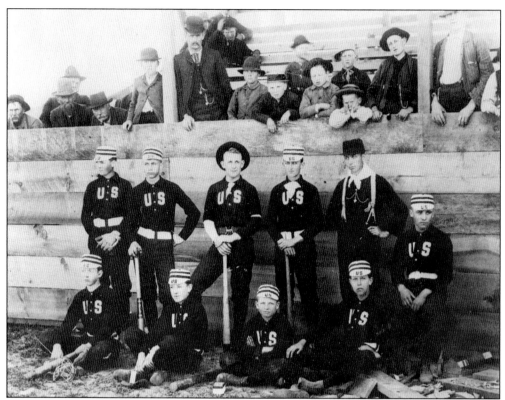

Historian Lillian Otness donated this 1890s photograph to the Latah County Historical Society. Moscow had a town baseball team as early as 1885 and, by 1892, had formed a baseball club that competed against town teams throughout the region.

Little is known about the Moscow Cubs, seen here in 1931; it may have been a youth team sponsored by the local Kiwanis organization.

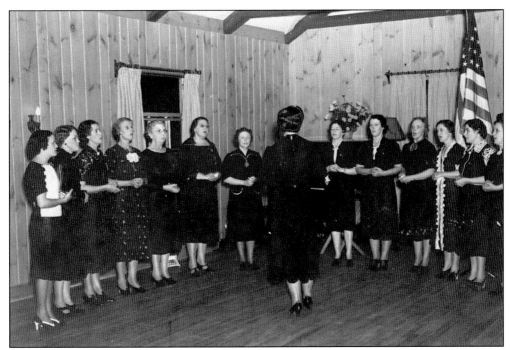

The American Legion Auxillary chorus rehearses in this 1930s photograph. The location appears to be the American Legion Cabin, located on Howard Street, and according to information on the back of this photograph, the director is Lois Russell.

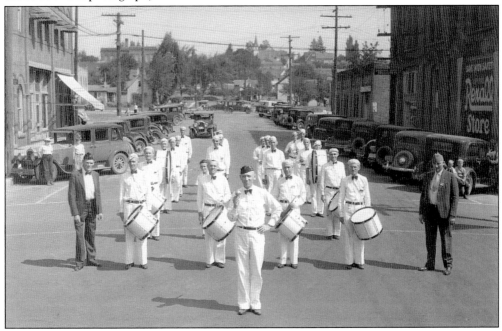

Found among a scrapbook of photographs in the archives of the Latah County Historical Society, this image shows a parade sponsored by the American Legion sometime in the 1930s. Unfortunately, none of the men are identified. The location appears to be the east side of Fourth Street in downtown Moscow.

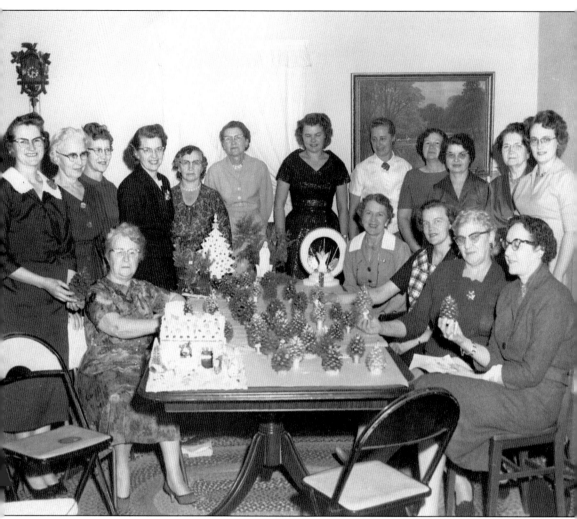

In the early 1950s, members of the Moscow Garden Club prepare Christmas favors for the residents of Moscow's nursing home. The woman standing on the far left is Vivian Hofmann, and the woman standing on the far right is Winifred Dixon.

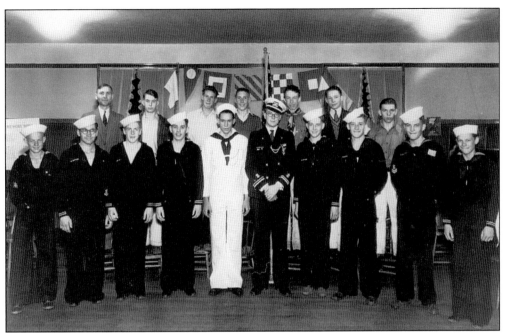

Sea Scouting, associated with the Boy Scouts of America, was founded in the U.S. in 1912. In June 1932, Moscow's chapter was named Sea Scout Ship Sampson, most likely in honor of Harry Sampson. Pictured, from left to right, are (first row) Leslie Songstad, Marion Horton, Dick Axtell, Homer David, Donald Dewey, Lloyd Berg, Bob Retherford, Kenneth Hungerford, Dean Lemon, and Vernon Gossett; (second row) Harry Sampson, Lewis Orland, Willard Faulkner, Bill Hunter, Howard Johnson, Wilbur Vincent, and Alf Meneely.

Boy and Cub Scouts appear to be promoting the sale of defense bonds sometime in the 1940s.

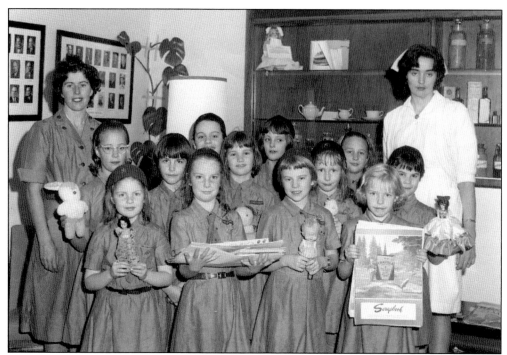

Pictured here during the 1950s is a troop of Moscow Brownies. The location could be Gritman Hospital. The identities of the children and women are unknown, as is the purpose for their assembly.

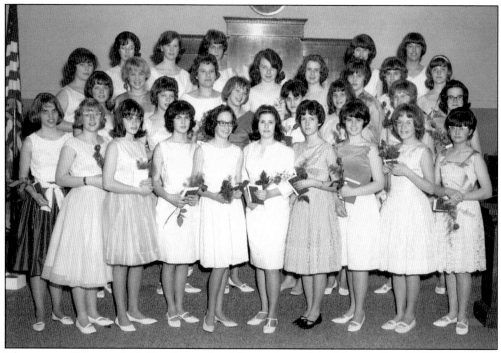

This group of Moscow Job's Daughters, the girl's auxiliary of the Masonic fraternal organization, was photographed during the early 1960s.

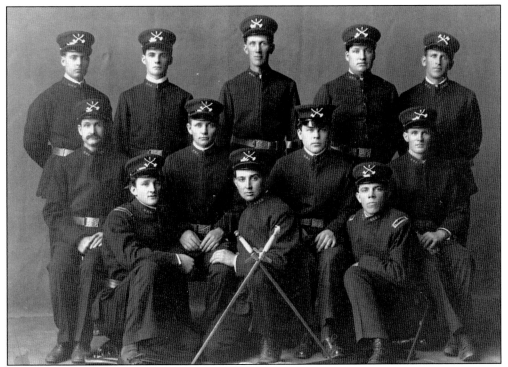

Members of the drill team of Moscow's chapter of the Modern Woodmen, a fraternal organization, are pictured here in the 1890s. Known as "Foresters," the drill team had a reputation for elaborate uniforms and meticulous drills.

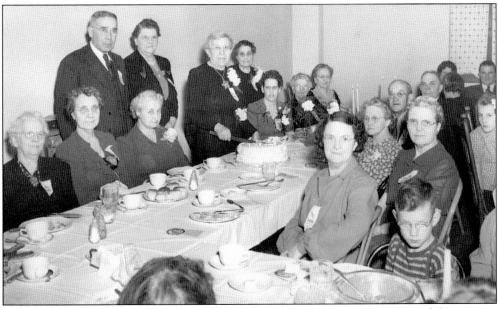

The location of this 1945 photograph is Moscow's IOOF Hall on Main Street, and the purpose for the celebration is the 50th anniversary of Moscow's Royal Neighbors Lodge. A fraternal organization for women, Royal Neighbors was founded in the United States around the turn of the 20th century.

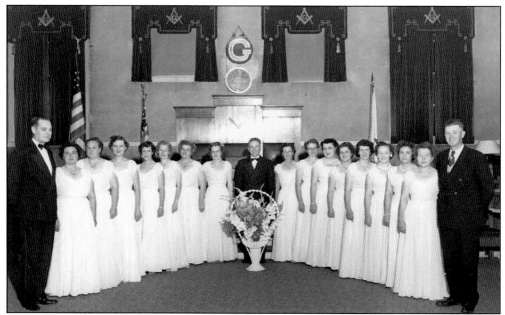

In 1952, the officers of Moscow's Order of the Eastern Star, a fraternal organization associated with the Masons, from left to right, are Kelly Cline, Vera Nokelby, Mildren Hawk, Winifred Aldapfer, Gladys Williams, Ada Smith, Martha Eshon, Lois Milenla, Wade Justice, Florence Cline, Nita Carson, Helen Justice, Helen Wilson, Kathryn Rogers, Arla Nelson, Elsie Smith, Nita Dix, and Les Rogers.

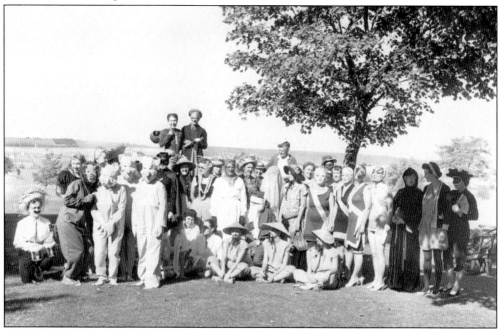

Because information on the back of this 1950s photograph identifies the location as Moscow's Elks Golf Course, it is likely that the women pictured here were associated with the local chapter of the Benevolent and Protective Order of Elks. While the group is called the "Staggerettes," the identities of the individuals are unknown.

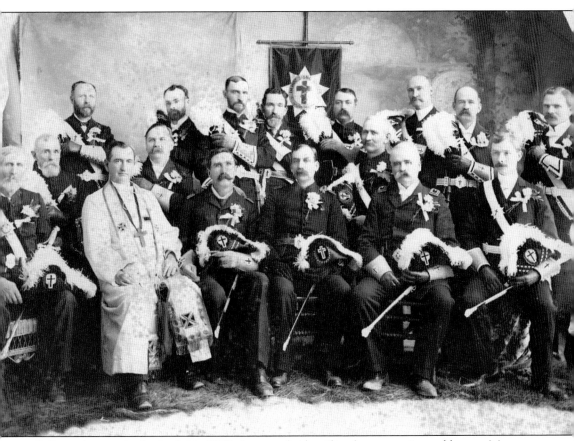

Information on the back of this 1897 photograph identifies the group pictured here as Moscow Commandery No. 3, most likely a local chapter of the Knights Templar fraternal organization. Pictured here, from left to right, are (first row) L. B. McCartor, W. W. Watkins, George I. Martin, Frank A. David, ? Buchanan, and W. P. Hooper; (second row) John Moore, I. C. Hattabaugh, and John W. Wolfe; (third row) W. W. Worthington, ? Frink, ? Miller, O. B. Edgett, C. A. S. Howard, Warren Truitt, Hiram T. French, and Eugene Gillette.

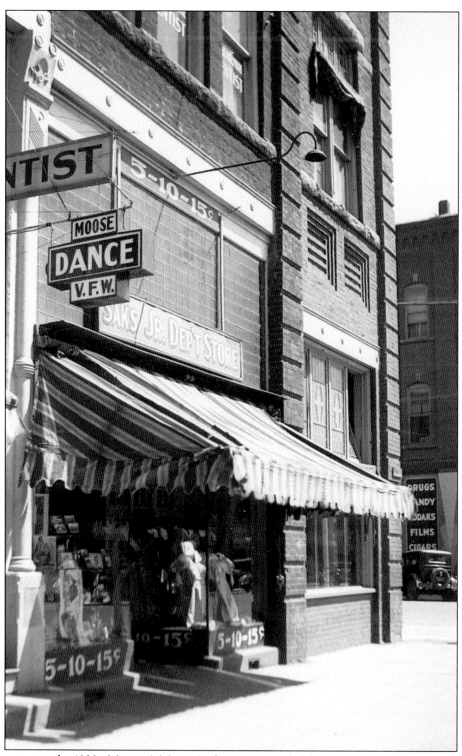

Sometime in the 1920s, Moscow's Moose Lodge maintained club rooms and a dance hall on the second floor of the McCartor Building North, located in the 300 block of South Main Street.

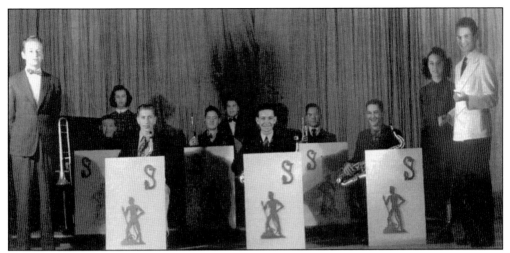

In 1937, the dance band of Moscow High School was known as the Seven Devils. Pictured here, from left to right, are Chuck Boyd, vocals; Chuck Luke, trombone; Margorie Call, piano; Leonard Heick, saxophone; Bill Stewart, trumpet; Barney Loomis, drums; Ernie St. John, saxophone; Roger Hungerford, trumpet; Bob Mortenson, saxophone; Winifred Hart, vocals; and Bill Wall, band leader.

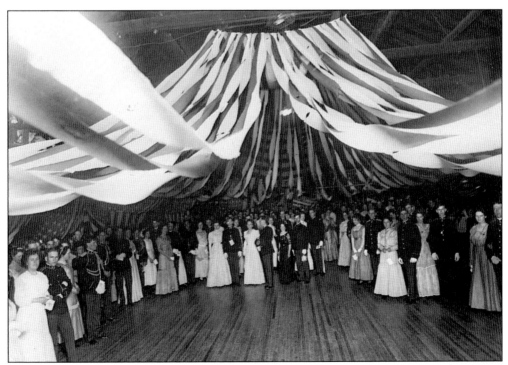

One of the University of Idaho's long-standing galas is the annual Military Ball. The location of the 1911 dance, pictured here, was probably the Memorial Gymnasium on the Idaho campus.

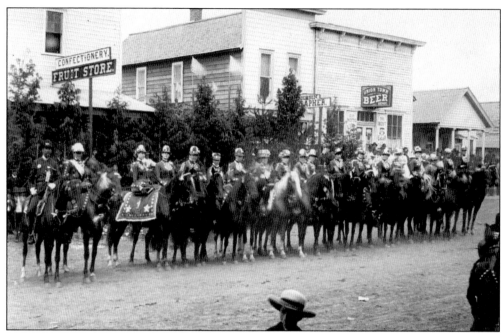

Information on the back of this 1888 photograph identifies the location as the west side of Main Street, but the specific location is unknown, as are the identities of all the individuals pictured here. The man at far left is Robert H. Barton, and the group may have been a women's unit of the Grand Army of the Republic, assembled for a parade.

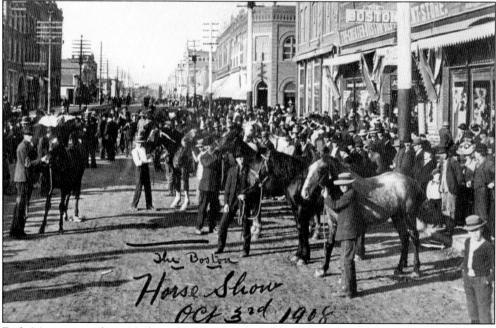

Early Moscow merchant Nathaniel Williamson started a series of street fairs held annually each fall. The horse show in this 1908 photograph was probably part of one of Williamson's fairs. Boston was the name of Williamson's general store, which was located in the Shields Building in the 400 block of South Main Street.

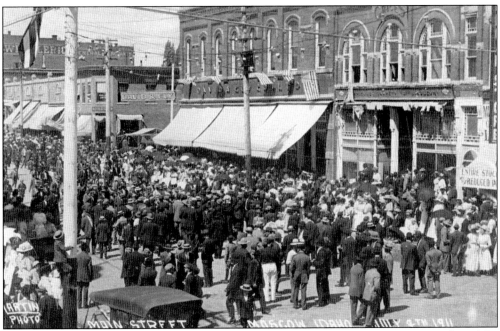

Independence Day celebrations in Moscow were once major celebrations that often lasted for several days. One wonders if the 1911 celebration, pictured here, rivaled the 1919 celebration. According to newspaper accounts, over 8,000 people jammed Moscow's streets for the 1919 festivities, which included an address by Gov. D. W. Davis.

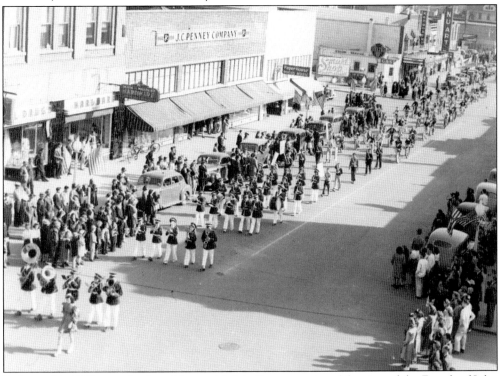

Perhaps this 1930s parade along Moscow's Main Street was in celebration of the Fourth of July.

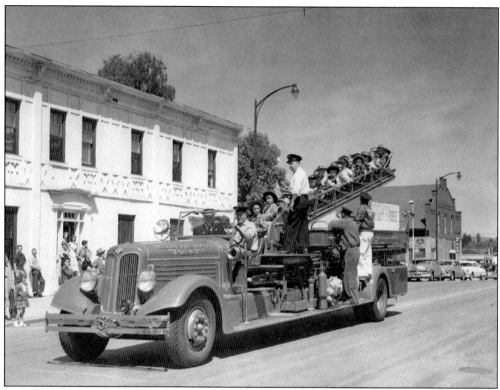

It is likely that this fire truck, its ladder loaded with children, was part of a University of Idaho Homecoming Parade in the 1950s. According to a newspaper report, the 1959 homecoming parade attracted nearly 12,000 people, who witnessed the complete collapse of the float from Lindley Hall, a men's dormitory on the Idaho campus.

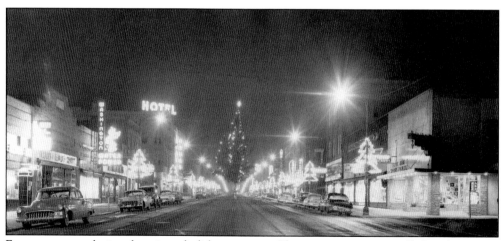

For many years, during the winter holiday season, a Christmas tree was installed in downtown Moscow around the intersection of Main and Fourth Streets, such as the one shown in this *c.* 1955 photograph.

Athletic competition long has been an important part of Moscow recreation, but most of the photographs in the archives of the Latah County Historical Society document male high school and collegiate teams. Thus, this photograph of the 1917 Moscow High School girls' basketball team is a rarity. Pictured, from left to right, are Flora Loomis, Olive Frazier, Ruth Burton, Ruth Harris, Pearl Buchan, and Mabel Drury.

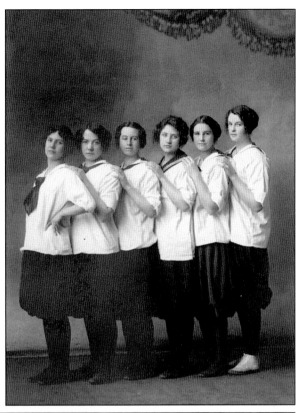

The 1917 Moscow High School football team poses in front of what is now the 1912 Center, Moscow's Community Center, on Third Street, across from the present-day site of Moscow High School. George Fallquist recalled the 1915 Moscow High School gridiron season: "Resplendent in new red and white uniforms with tan pants and fine equipment, we really looked and acted like a good team."

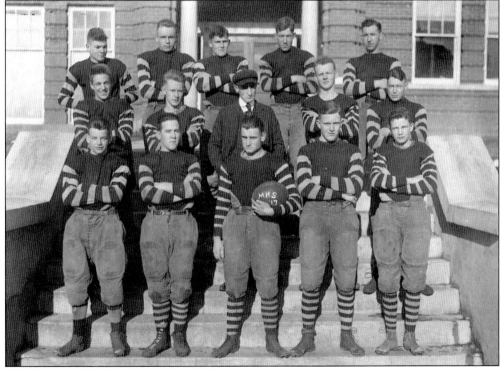

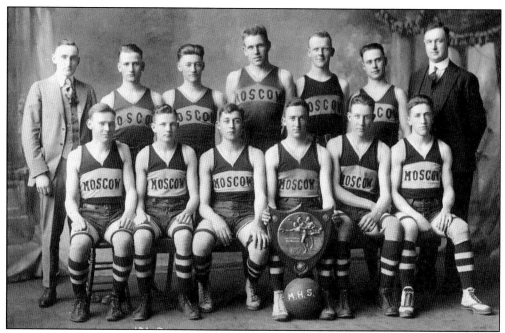

During the 1917–1918 school year, the Moscow High School basketball team was state champion, an impressive feat considering that high school athletics in Moscow did not begin until 1914. According to a February 6, 1918, account in the *Wocsomonian*, the MHS student newspaper, the Moscow team "literally swamped their opponents [Lewiston High School] in the first half, almost tripling the score."

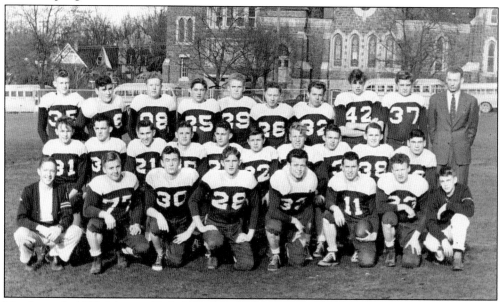

Members of a 1930s Moscow High School football team pose for a group photograph. According to an account of the 1931 football season that appeared in *Bear Tracks*, the MHS yearbook, "The St. John [Washington] game, played in a sea of mud, resulted in a stiff old-fashioned football tangle with both teams relying mostly upon straight line plays." In the background is the Methodist Episcopal Church.

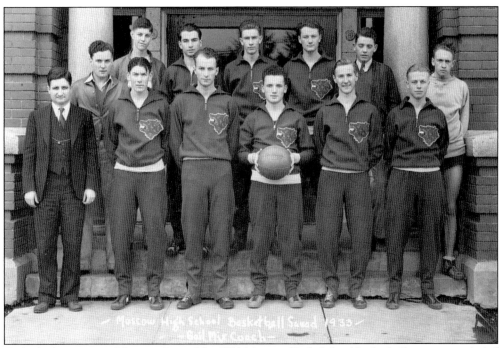

Only the last names of the members of the 1933 Moscow High School basketball team are included with this photograph. Pictured, from left to right, are (first row) Mix (coach), Tracy, Smith, Hall, Gauss, Roise, and Heath; (second row) Monnett, Hall, Kelley, Fogel, and David.

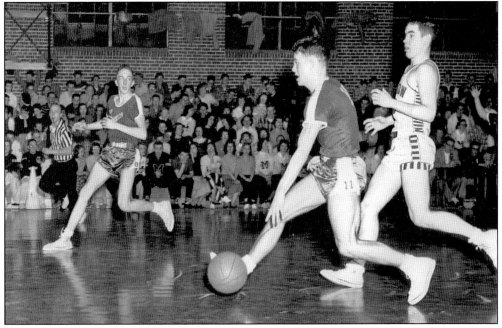

This 1940s basketball team hits the court located inside Moscow High School. According to an account of the 1948 basketball season that appeared in *Bear Tracks*, the MHS yearbook, the 1947–1948 team notched "thirteen triumphs out of a spectacular twenty-six game campaign." The court pictured here is still in use today.

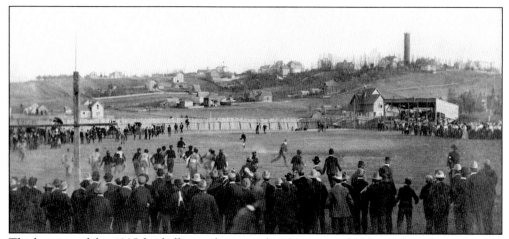

The location of this 1905 football game between the University of Idaho and Washington State College (now Washington State University) is uncertain but may have been east of the campus near Sixth Street. For many decades, there was an intense football rivalry between Idaho and Washington State.

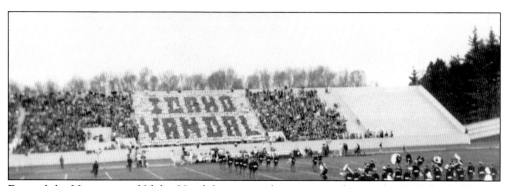

Fans of the University of Idaho Vandals express their support during the 1941 football game between the Vandals and the Washington State College Cougars. This game took place in Pullman, home of WSC, eight miles to the west of Moscow.

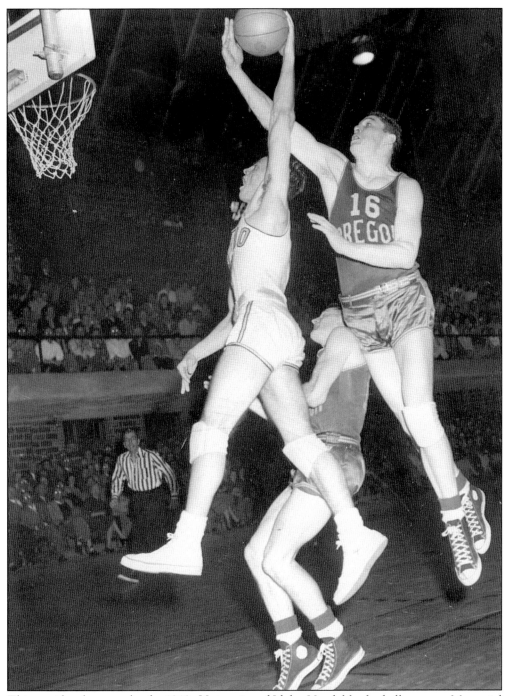

This terrific photograph of a 1940s University of Idaho Vandal basketball game at Memorial Gymnasium appeared in *Life* magazine. Moscow resident Al Hofmann was the photographer.

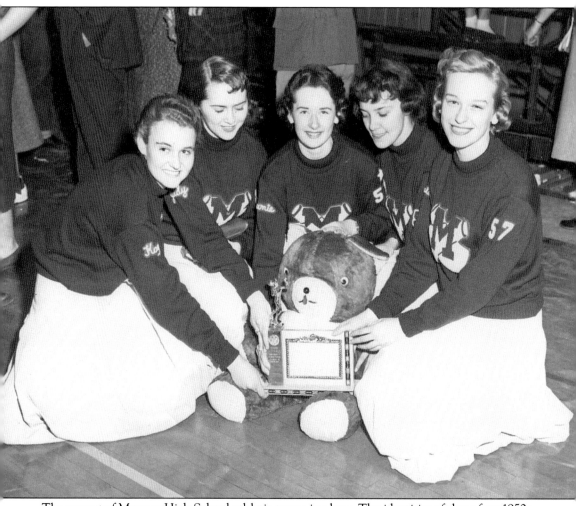

The mascot of Moscow High School athletic teams is a bear. The identities of these four 1950s-era MHS cheerleaders are unknown.

Six

IN CLASS

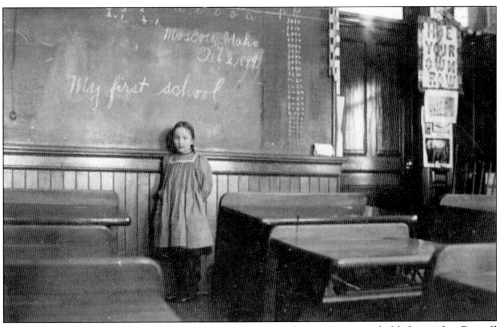

Because the date on the blackboard is February 2, 1899, this room was probably located in Russell School, built in 1884 on the block between First, Adams, A, and Jefferson Streets. The identity of the little girl in this photograph is unknown.

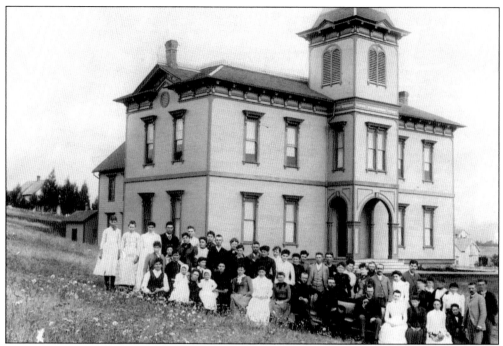

The group posing in front of the first Russell School in the 1890s is most likely teachers (and their families) of the Moscow School District. This school building burned down in 1912. The present-day Russell School first opened its door on Monday, October 14, 1928.

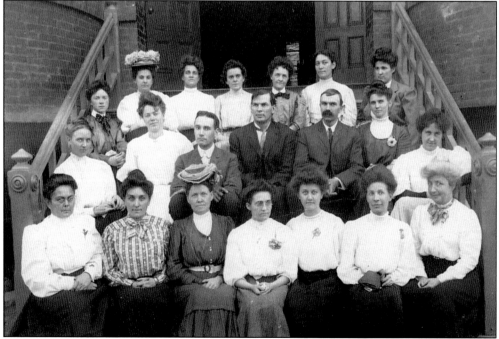

It is likely that the people assembled for this c. 1900 photograph are Moscow High School teachers; the location is probably Moscow's first brick school building, which stood on the south side of Third Street between Jefferson and Adams Streets.

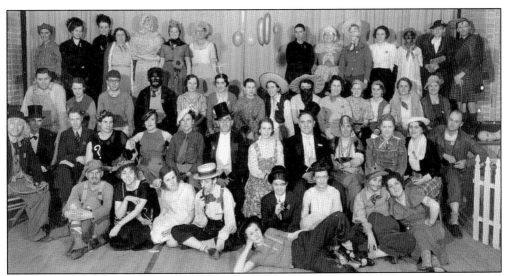

These Moscow teachers, gathered here sometime in the 1930s, from left to right, are (first row) Mr. Ostness, Ina Peterson, Julia Hunter, Marian McQuaid, Elizabeth Stickney, Maybelle Jones, Alice Reed, Ona Johnson, and Florence Cline (on floor); (second row) Frances Nonini, Ted Cornell, Paul Woods, Doris Shea, Ann Roe, Lillian O'Callaghan, Fulton Gale, Louise Hauck, Les Roberts, Mrs. Rutherford, Doris Crawford, Mrs. Hutchinson, and Mr. Hirschler; (third row) Mrs. Woods, Verne Wilson, Lewis Miles, Mr. Pittwood, Miss O'Donnell, Mrs. Ostness, unidentified, Thelma Pierce, unidentified, Bonnie Sather, unidentified, Mrs. Gale, Thelma Decker; (fourth row) Evelyn Jones, Hildegarde Durham, Lena Shatzer, Madelyn Almstead, Vivian McKinley, Lena Whitmore, Carol Burkehardt, Mrs. Perry, unidentified, Myrtle Larson, Irene Peterson, Mrs. Miles, Mr. Perry, and unidentified.

Students of Moscow High School, c. 1890, from left to right, are (first row) Lillie Lieuallen, Gemma Cable, Miss Jones, Mary Spotswood, and Margaret Scully; (second row) Principal J. C. Muerman, Marguerite Van DeWalker, Ada Cable, and M. M. Lane.

Students of Moscow High School, *c.* 1896, from left to right, are (first row) Mabel Moody, Maude Barton, Principal J. C. Muerman, and E. Whitmore; (second row) Viola McCartor, Will Burton, Nettie Cook, May Gould, and Mary Cole; (third row) Alberta Kirkwood, Olaf Larson, Charles Frazee, and Verna David.

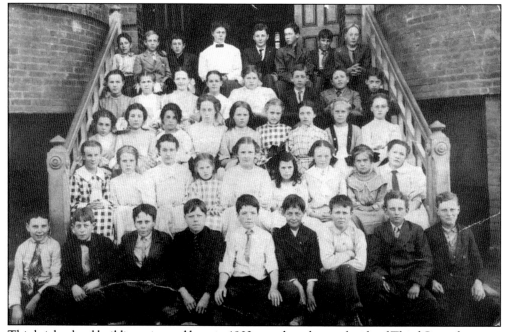

This brick school building, pictured here in 1903, stood on the south side of Third Street between Jefferson and Adams Streets, where the Moscow High School Annex now stands. The building was called Moscow High School, but only one of its 10 rooms was used for high-school classes.

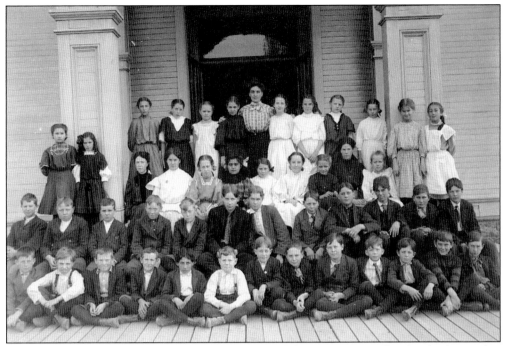

Irving School was constructed in 1901 on the site of the present Russell School. The teacher of this *c.* 1901 class was Ione Adair, daughter of physician William Adair. The school was razed in 1926.

The students of the Irving School's fourth grade pose on the steps of their school for a class photograph in 1904. The teacher was Lena Whitmore.

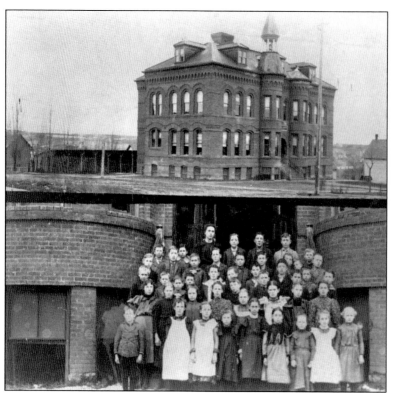

At the top of this unusual composite photograph is Moscow's first brick school building, located on Third Street. Below the school is Mattie Headington's class, pictured around 1903.

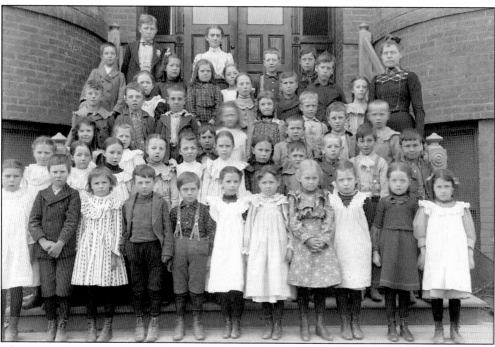

Clarice Moody Sampson is the fourth child from the left in row six. In 1902, Clarice was in the second grade, and her teacher was Mr. Eckman. The eerie blurring of the face of the child in the center of the photograph is the result of her moving as the photograph was taken.

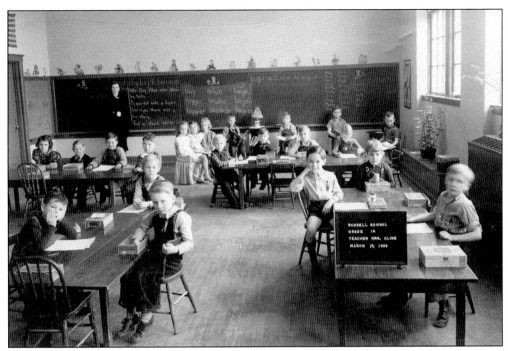

Florence "Sadie" Cline taught this 1938 first-grade, Russell School class. Note the cigar boxes that appear to serve as pencil boxes.

Miss Wilson taught this 1939 second-grade class at Russell School. In 1989, three Russell School students, Marisa Swank, Emily Shupe, and Matt Steenberg, concluded in their history of Russell that the school "has been through very tough times. It has been rebuilt four times and has been destroyed by fire. Russell has been moved from one place to another and the location has finally satisfied the Moscow people."

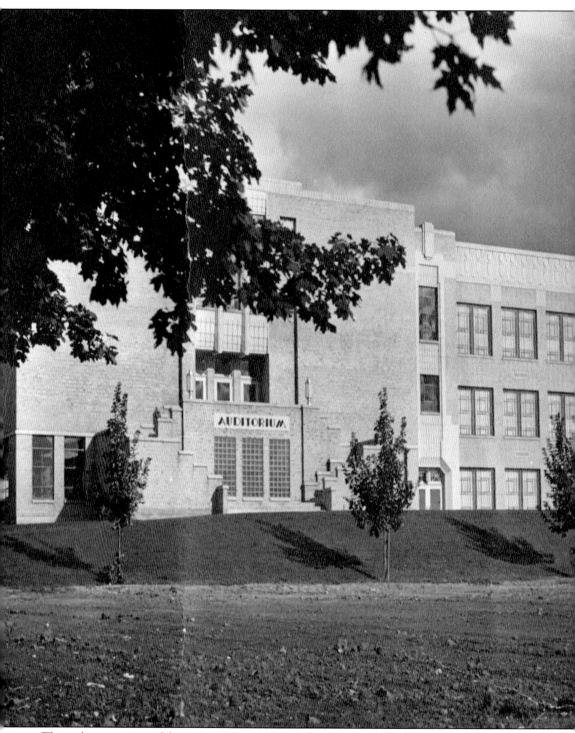

The striking entrance of the present Moscow High School, with its distinctive art deco decoration, is now hidden behind an annex constructed of cinder blocks. The building was constructed as a

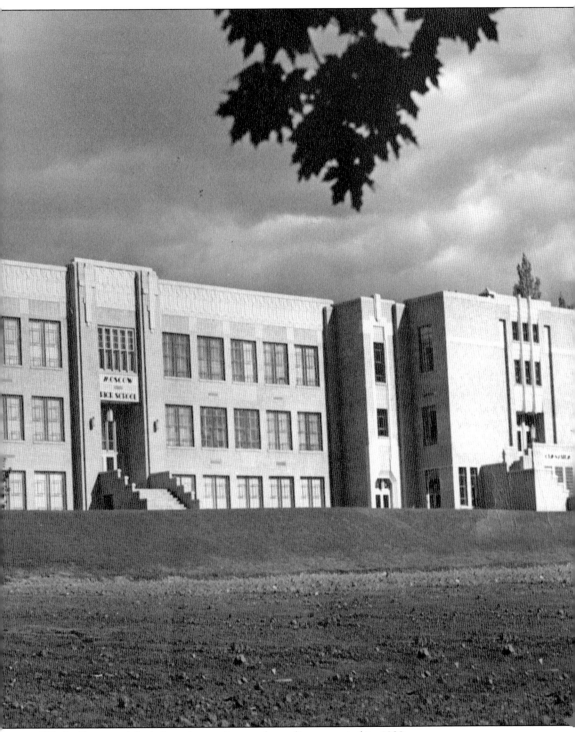

Works Progress Administration project and was first occupied in 1939.

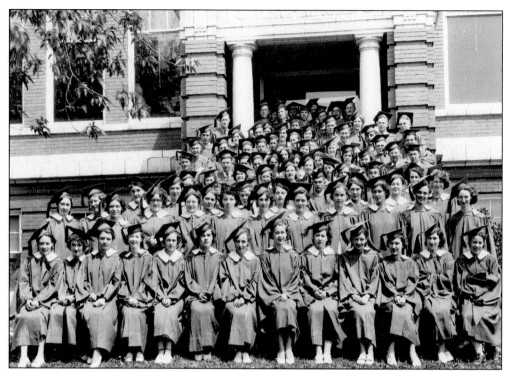

When the Moscow High School class of 1935 graduated, the school was located in the building at 410 East Third Street, which served as the high school from 1912 until 1939. It is now a community center known as the 1912 Center.

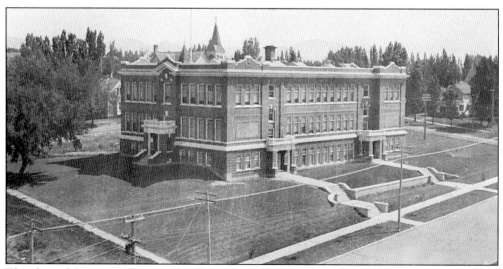

This date of this aerial photograph of Moscow High School is unknown, but it must have been taken shortly after the building's construction in 1912. This building was placed on the National Register of Historic Places in 1992.

Information on the back of this photograph identifies these students as members of the Whitworth harmonica band. According to local historian Lillian Otness, after the current high school building was occupied in 1939, the name "Whitworth" was transferred from the grade school on the south side of Third Street to the 1912 high school. Isa Whitworth was a beloved Moscow teacher.

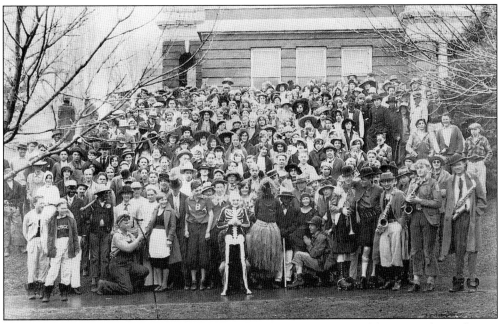

Old Clothes Day was a Moscow High School tradition for many years. "Old" seems to be a reference not to worn-out clothing but to clothing representing past eras. This photograph is dated 1930.

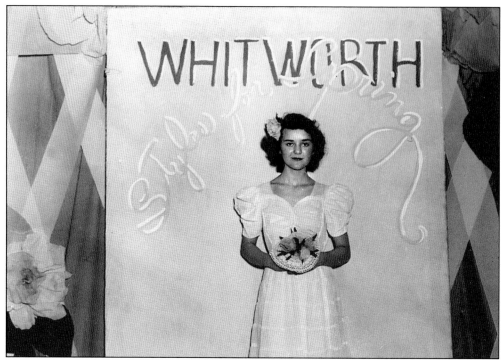

The identity of this young lady, apparently a student at Whitworth High School, is unknown. At one time, Whitworth students followed a creed proclaiming that they were to be trustworthy; friendly; studious; cheerful; loyal to teachers, home, parents, country, and city; respectable; brave; and clean.

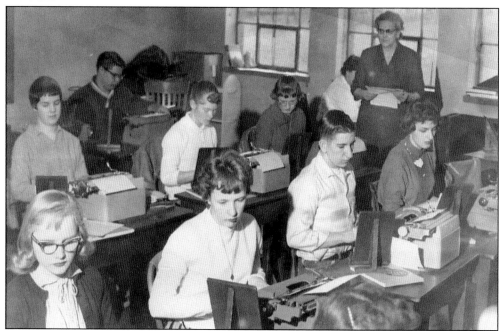

Carol Walenta, wife of University of Idaho law professor Thomas Walenta, teaches Moscow High School students how to type in the 1950s.

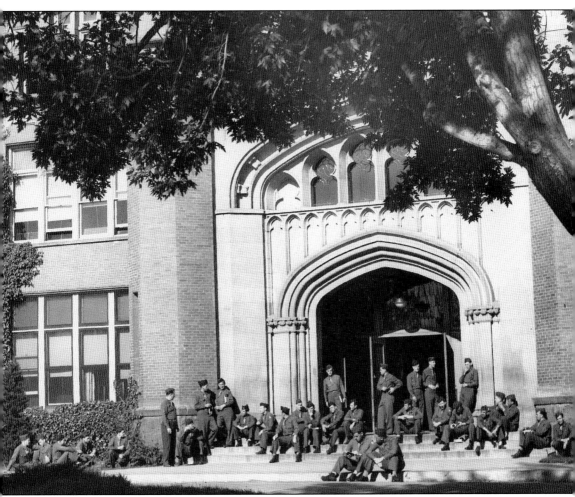

One of the landmark buildings on the University of Idaho campus is the Administration Building; its rooms are still in use today as administrative offices and classrooms. The specific date of this photograph is unknown, but the presence of so many soldiers on the building's steps indicates that it was taken sometime after December 7, 1941. Founded in 1889, the University of Idaho is the state's land-grant institution.

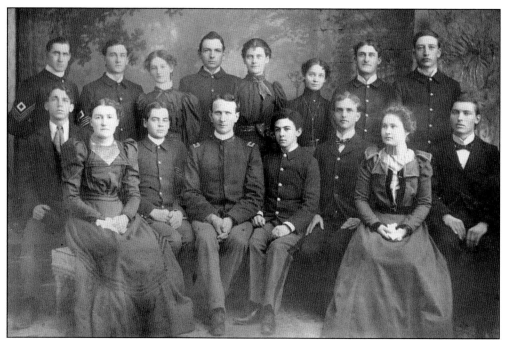

Members of the University of Idaho class of 1899, from left to right, are (first row) Robert Barkwell, Marie Cuddy, Harold Gilbert, Henry Lancaster, Benjamin Oppenheimer, D. Russell Morris, Effie May Wilson, and Andrew Peterson; (second row) Charles Fisher, Jesse Wright, Winifred Booth, Clarence Edgett, Marcie Shannon, Lucille Mix, Fred McConnell, and Lawrence Corbett.

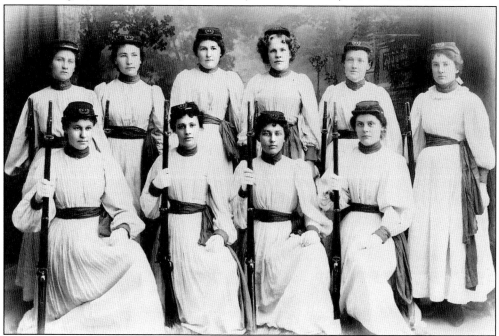

Unfortunately, the identities of the 1897 University of Idaho Company C, University Cadets are unknown. However, according to Keith C. Petersen in his illustrated history of the University of Idaho, "this women's company gained a reputation for its precise drills."

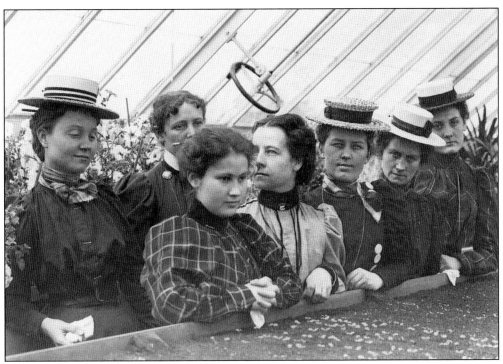

Professor Huntley's horticulture class, the university's first, meets in a campus greenhouse in 1899.

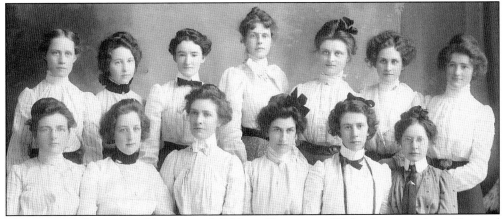

These young ladies, pictured here around 1900, are University of Idaho theatre students. One goal of today's Department of Theatre and Film is to enrich the quality life of the university campus and the broader Palouse community.

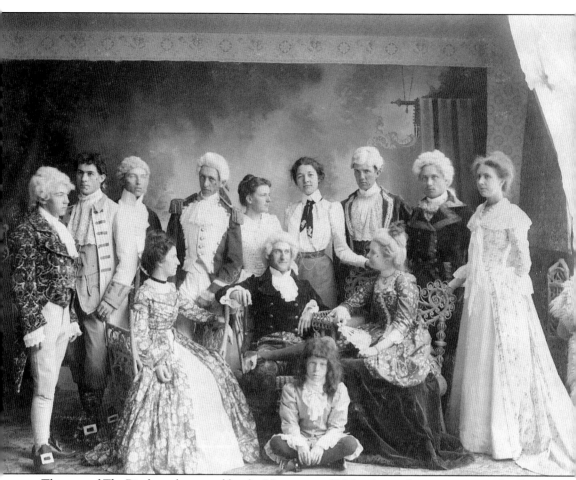

The cast of *The Rivals*, a play staged by the University of Idaho drama department, pose for this photograph in June 1900.

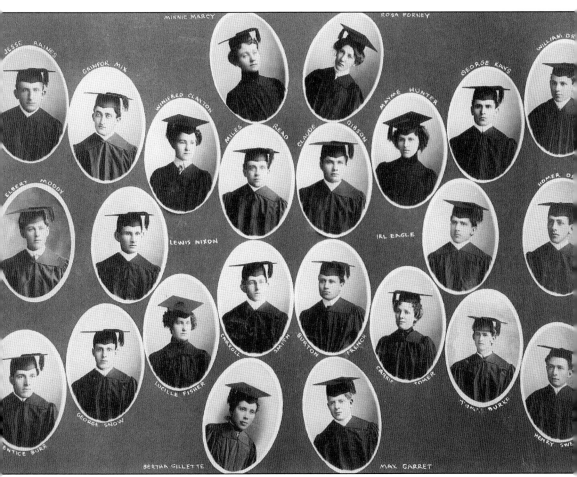

This photograph documents the members of the University of Idaho class of 1901 in an unusual fashion.

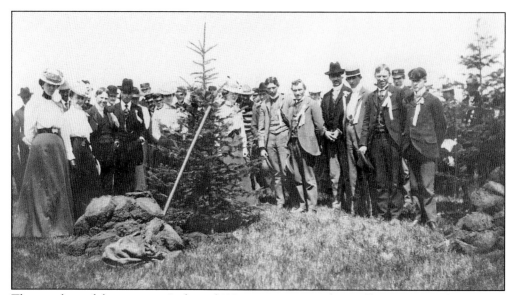

The members of the university's class of 1901 commemorate their collegiate careers by planting a tree on the lawn of the Administration Building. The class of 1901 was responsible for starting the *Argonaut*, the student newspaper still in operation today.

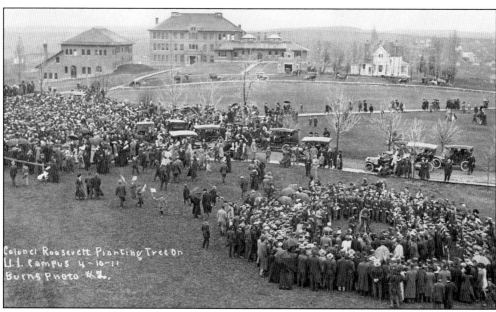

Former president Theodore Roosevelt visited Moscow and the University of Idaho on April 9, 1911. After addressing a large audience from the steps of the Administration Building, Roosevelt planted a blue spruce tree in an area of the campus that came to be known as the Presidential Grove.

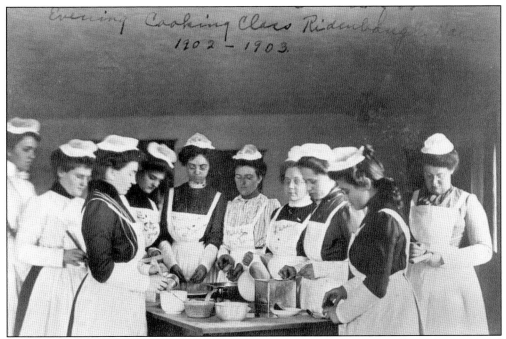

The University of Idaho was one of the first schools in the Northwest to offer a Department of Domestic Science, which eventually became a school of home economics. The women pictured here are members of the department's first class in 1902.

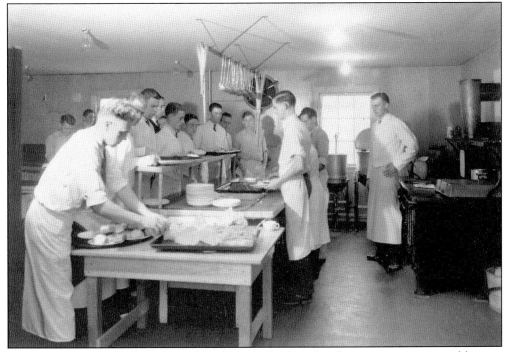

Information on the back of this 1930s photograph identifies the young men pictured here as members of a "men's cooking class." It is not known if men's cooking classes were regular offerings of the university's home economics curriculum.

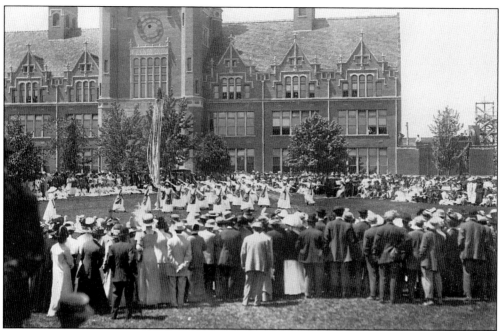

For many years, May Day celebrations were an important part of the university's social life, as seen here in 1915–1916. The roots of the celebration go back to 1910 when the dean of women, Permeal French, organized the first Campus Day. The morning was devoted to tidying up the campus and the afternoon to relaxation and entertainment. The highlight of the festivities was the Maypole dance performed by the university's female students.

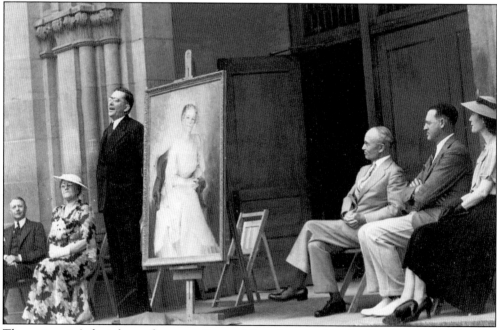

The university's first dean of women, Permeal French, seated in the floral-patterned dress, is honored in 1938 for her nearly three decades of service to the university. She retired in 1936.

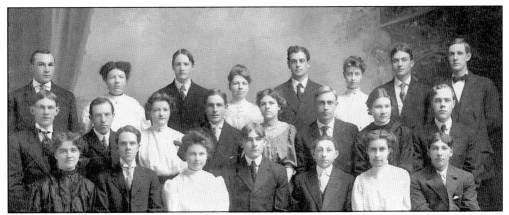

The only identified member of the University of Idaho class of 1910 is Eva Anderson, second row, third from the left.

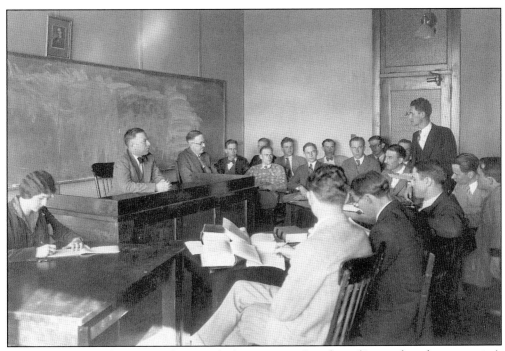

It is believed that this 1930s photograph documents a "mock trial" staged at the university's College of Law. For many years, the college, which was established in 1909, was located in the Administration Building. In 1973, faculty, staff, and students moved into the building that houses the college today—the Albert A. Menard Law Building.

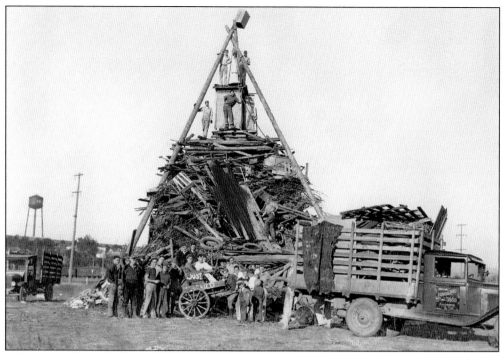

A longtime University of Idaho homecoming tradition was the staging of an elaborate bonfire by freshmen. This photograph documents preparation for one such bonfire in the 1930s.

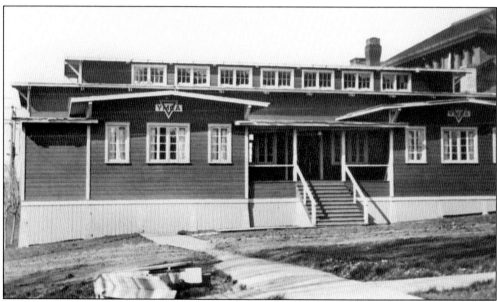

In 2000, the structure known as the "U Hut" was razed to make room for the Idaho Commons building. Prior to the building's demolition, two murals painted by University of Idaho students in 1936, and partially funded by the Works Progress Administration, were removed from the building's walls and preserved by art faculty members David Giese and Val Carter.

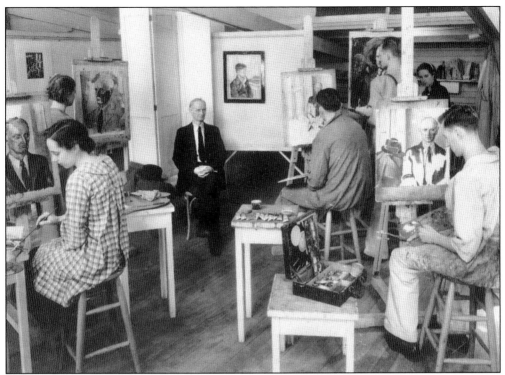

Among the members of the University of Idaho art class pictured here is Alfred Dunn, seated at far right. Dunn went on to the join the university's art faculty and also worked as a crime artist for the FBI.

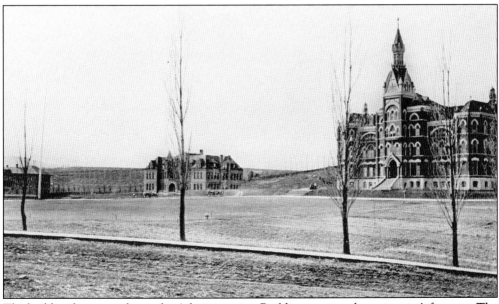

The building known today as the Administration Building was not the university's first one. The first Administration Building, destroyed by fire in 1906, is at far right. In the center is the Mines Building, which was razed in 1951 to make way for the home economics building, and to the far left, Ridenbaugh Hall, which is still in use today.

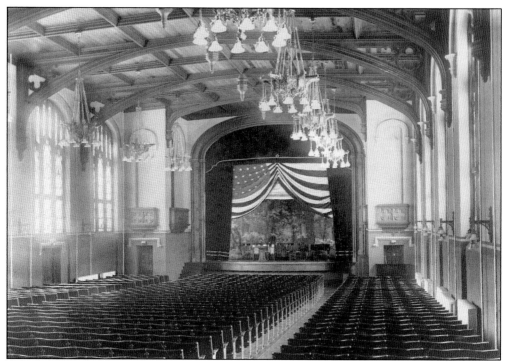

The auditorium of the Administration Building, seen here in this 1930s iamge by Moscow photographer Charles Dimond, still welcomes performers and audiences today. The auditorium-chapel was constructed in 1911–1912.

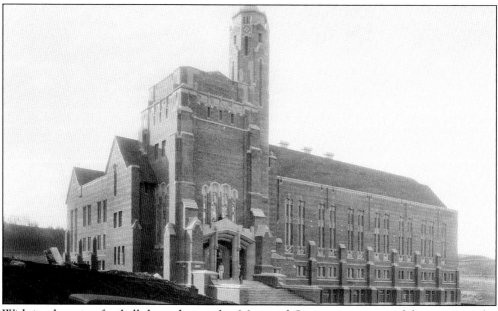

With its charming football-themed gargoyles, Memorial Gymnasium is one of the most popular buildings on the university campus. First occupied in 1928, and expanded in the early 1950s, the building originally was constructed as a memorial to Idaho citizens who lost their lives in World War I. It was placed on the National Register of Historic Places in 1977.

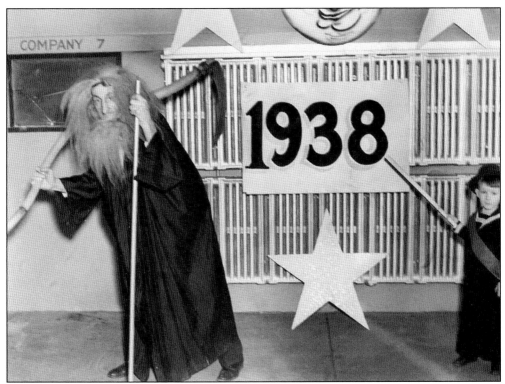

Generally the site of athletic competition, Memorial Gymnasium also has provided space for dances, musical performances, and lectures. In 1938, Moscow resident Perry Carter, as Father Time, welcomes the New Year. The identity of the little boy at far right is unknown.

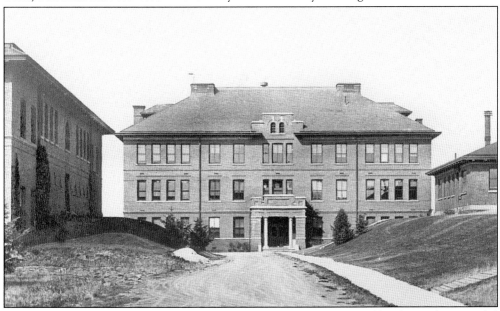

Still in use today, Morrill Hall, named for the U.S. senator who introduced legislation that provided free land for the founding of land-grant universities, was first occupied in March 1907. Originally it housed the College of Agriculture and the Agricultural Experiment Station.

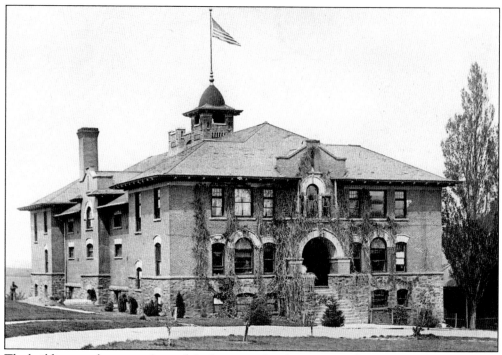

The building now known as Art and Architecture South was originally constructed as an armory and gymnasium. It was placed on the National Register of Historic Places in 1983.

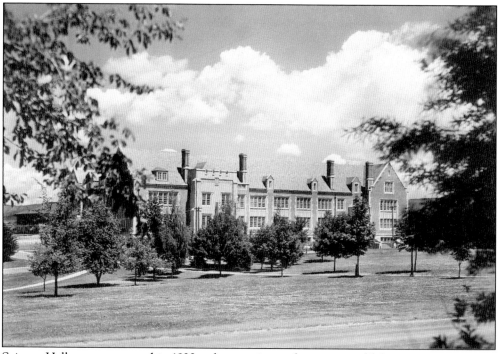

Science Hall was constructed in 1923 to house science classrooms and laboratories; its purpose remains the same today.

In 1910, forestry professor Charles Houston Shattuck began planting trees in a weedy slope on the university campus. Today the Shattuck Arboretum is a grove of mature trees with some of the finest specimens in the western U.S. In this c. 1915 photograph, an individual, probably Shattuck, stands next to a young, black locust tree.

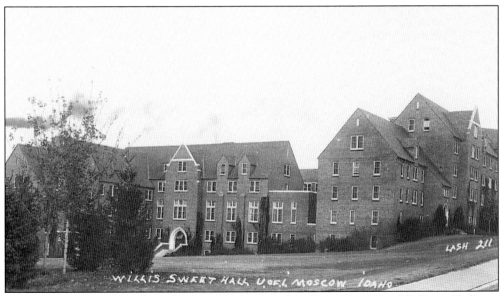

Now known as Brink Hall (in honor of Moscow author Carol Ryrie Brink), Sweet Hall was constructed in 1936 as a men's dormitory. It was originally named in honor of Willis Sweet, who helped found the University of Idaho in Moscow.

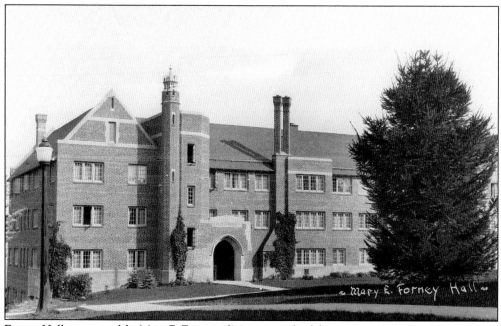

Forney Hall was named for Mary E. Forney of Moscow, wife of the university's first acting president, James E. Forney. Constructed in 1923 as a women's dormitory, it is used today for offices.

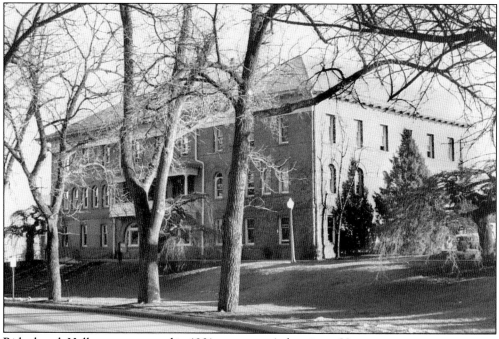

Ridenbaugh Hall was constructed in 1901 as a women's dormitory. Housing music practice rooms, today it is named for Mary E. Ridenbaugh, an early officer of the Board of Regents. The building was placed on the National Register of Historic Places in 1977.

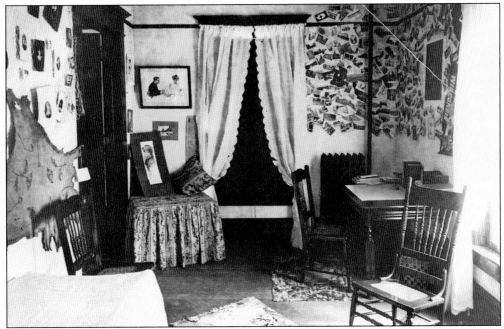

Today few dorm rooms on the Idaho campus can match the hominess of the one pictured in this c. 1910 photograph of Ridenbaugh Hall, then a dormitory for women. According to a noticeably sarcastic account in an early edition of the *Argonaut*, the student newspaper: "the inmates of Ridenbaugh are enjoined from loitering on campus with any young man on weekdays."

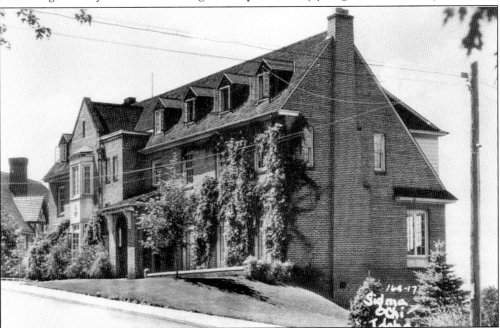

Built in 1924, the Sigma Chi house, pictured here in the 1930s, now houses the Beta Gamma chapter of Phi Kappa Tau, established at Idaho on October 5, 1947. Today the Sigma Chi house is located on Nez Perce Drive, on the southern perimeter of the campus. The Gamma Eta chapter of Sigma Chi was founded on March 15, 1924.

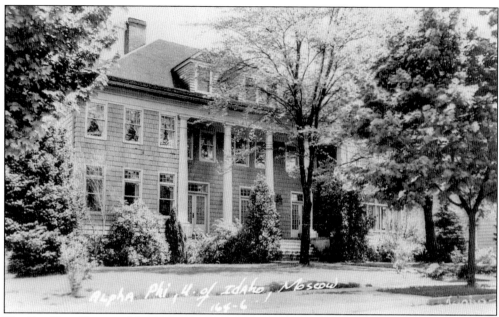

The Beta Zeta Chapter of the Alpha Phi sorority was founded on the University of Idaho campus on June 12, 1928. The house pictured in this 1930s photograph still serves as the sorority's home.

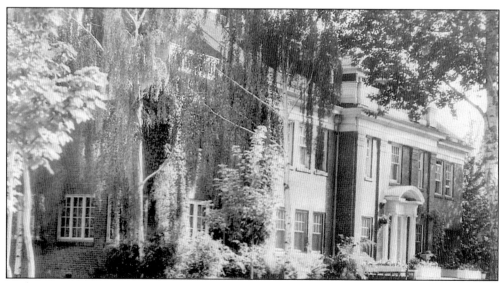

With Burton L. French (who went on to represent Idaho in Congress) as its first member, the University of Idaho chapter of Phi Delta Theta was founded on November 25, 1908. This house is probably the fraternity's second house, built in 1920–1921. The fraternity's current house was erected in 1968.

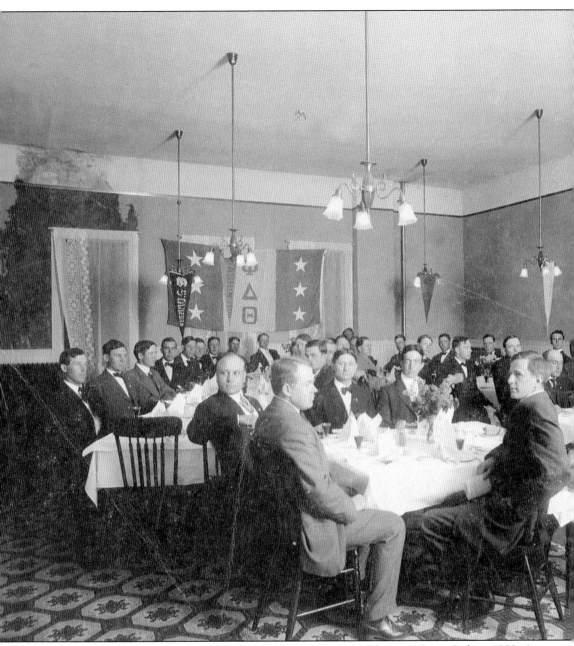

Members of the Phi Delta Theta fraternity gather at Moscow's Pleasant Home Café in 1908. A few of the student founders of this fraternity on the Idaho campus were brothers Earl and Homer David, sons of Moscow merchant F. A. David; Loyal Adkinson; and Robert Ghormley, who would become a vice admiral in the U.S. Navy.

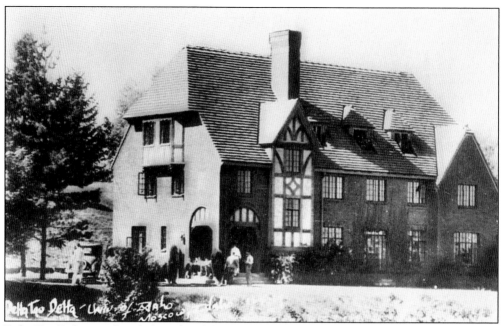

Delta Tau Delta was founded on the Idaho campus on May 2, 1931, with Dean Edward Iddings of the College of Agriculture as its faculty founder. The house pictured here, still serving as the fraternity's home, was constructed in the 1930s.

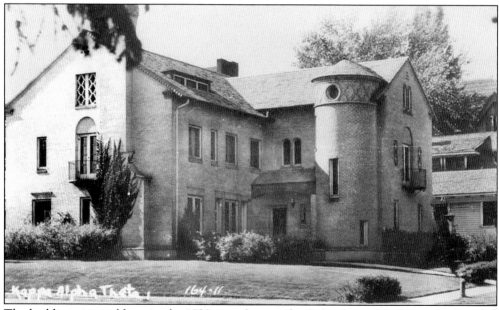

The building pictured here in the 1930s now houses the Delta Sigma Phi fraternity, founded at the University of Idaho on May 25, 1950. At one time, it had housed the Kappa Alpha Theta sorority.

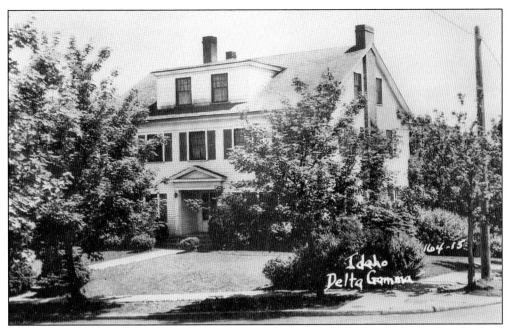

While the Delta Gamma sorority was founded at the University of Idaho in 1911, its precursor was Beta Sigma, which was organized in 1899 by the wife of a faculty member. The building pictured in this 1930s photograph remains the Delta Gamma house today.

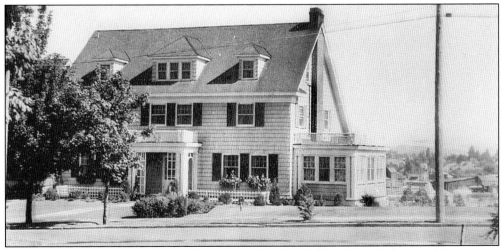

Pictured here in the 1930s is the Gamma Phi Beta sorority building. The Xi chapter of this sorority was founded at the University of Idaho on February 3, 1910.

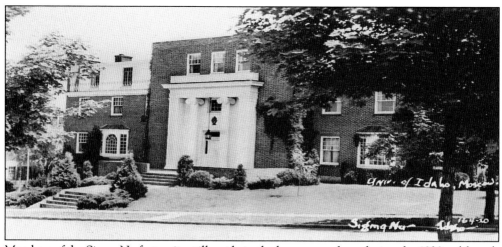

Members of the Sigma Nu fraternity still reside in the house, seen here during the 1930s, although it now has an extensively remodeled interior. The Delta Omicron chapter of Sigma Nu was founded at the University on March 25, 1915.

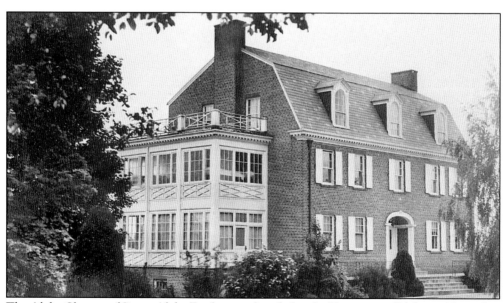

The Alpha Chapter of Sigma Alpha Epsilon was founded at the University of Idaho on November 1, 1919. Today members of the fraternity reside in the same house, which was placed on the National Register of Historic Places in 1993.

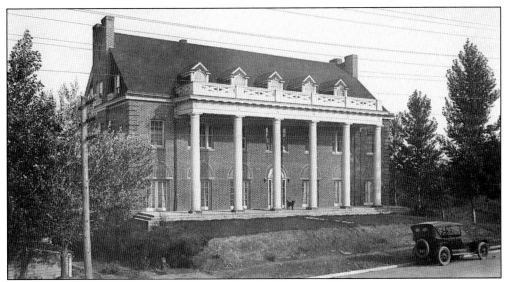

This house seen in this 1930s photograph still serves as home to members of Idaho's Kappa Sigma fraternity, founded at the university on September 15, 1905. The house was designed by renowned architect Kirkland Cutter and was completed in 1916. In 1996, it was placed on the National Register of Historic Places.

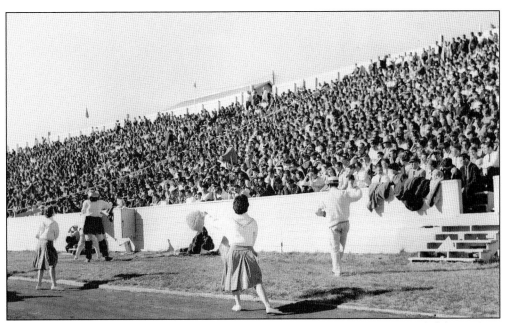

With his back to the camera but facing the crowd, Joe Vandal, the University of Idaho mascot, and University of Idaho cheerleaders rally Vandal fans during a football game at Neale Stadium in the 1950s. Organized yells were once an important Idaho tradition. The first official yell, created in 1896, went "Rah! Rah! Rah! Idaho! Idaho! Boom! Bah! Bah!"

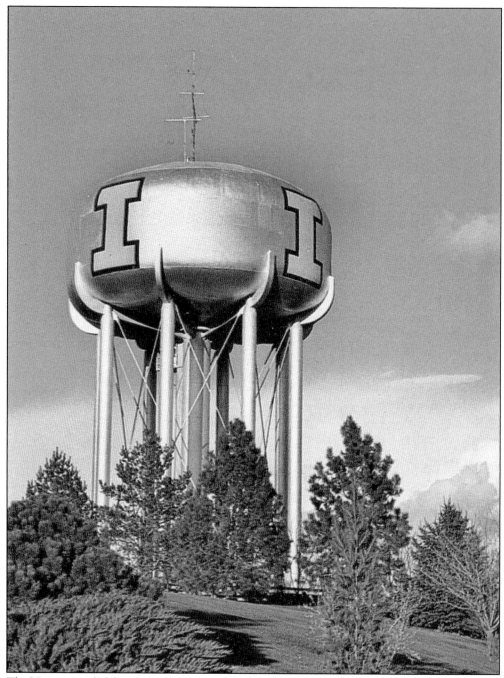

The University of Idaho campus water tower, built in 1952, sits on the southern edge of the campus near the "Prez Rez," the residence of the university's president. The tower stands 105 feet high and holds 500,000 gallons of water.

BIBLIOGRAPHY

Arnzen, Kenneth Joseph. *The First Hundred Years: A Centennial History of St. Mary's Church, Moscow, Idaho.* Moscow: Privately printed, 1982.

Boone, Lalia Phipps. *From A to Z in Latah County, Idaho: A Place Name Dictionary.* Idaho Place Name Project, 1983.

Idahonian. Moscow, Latah County, and University of Idaho Centennial Editions.

Monroe, Julie R. *Images of America: Latah County.* Charleston, SC: Arcadia Publishing, 2006.

Monroe, Julie R. *Moscow, Idaho: Living and Learning on the Palouse.* Charleston, SC: Arcadia Publishing, 2003.

Nielsen, Judith. Manuscript Group 133: Mark P. Miller Milling Company. Moscow, ID: University of Idaho Special Collections: www.lib.uidaho.edu/special-collections/Manuscripts/mg133.

Otness, Lillian W. *A Great Good Country.* Moscow, ID: Latah County Historical Society, 1983.

Petersen, Keith C. *This Crested Hill: An Illustrated History of the University of Idaho.* Moscow, ID: University of Idaho Press, 1987.

DISCOVER THOUSANDS OF LOCAL HISTORY BOOKS FEATURING MILLIONS OF VINTAGE IMAGES

Arcadia Publishing, the leading local history publisher in the United States, is committed to making history accessible and meaningful through publishing books that celebrate and preserve the heritage of America's people and places.

Find more books like this at
www.arcadiapublishing.com

Search for your hometown history, your old stomping grounds, and even your favorite sports team.

Consistent with our mission to preserve history on a local level, this book was printed in South Carolina on American-made paper and manufactured entirely in the United States. Products carrying the accredited Forest Stewardship Council (FSC) label are printed on 100 percent FSC-certified paper.

MADE IN THE
USA